Vermeer
Consciousness and the
Chamber of Being

Studies in the Fine Arts: Criticism, No. 16

Donald B. Kuspit, Series Editor

Chairman, Department of Art
State University of New York at Stony Brook

Other Titles in This Series

Vermeer
Consciousness and the Chamber of Being

by
Martin Pops

UMI RESEARCH PRESS
Ann Arbor, Michigan

Produced and distributed by
UMI Research Press
an imprint of
University Microfilms, Inc.
Ann Arbor, Michigan 48106

Library of Congress Cataloging in Publication Data

Pops, Martin.
 Vermeer : consciousness and the chamber of
being.

 (Studies in the fine arts. Criticism ; no. 16)
 Revision of thesis (Ph. D.)–Columbia University,
1965.
 Bibliography: p.
 Includes index.
 1. Vermeer, Johannes, 1632-1675. 2. Painting–
Psychological aspects. 3. Consciousness in art.
4. Interior architecture in art. 5. Environment
(Aesthetics) I. Title. II. Series.
ND653.V5P65 1984 759.9492 84-2564
ISBN 0-8357-1525-6

To
Susan Read
and
Matthew and Luke Battaglia

On whatever theoretical horizon we examine it,
the house image would appear to have become the
topography of our intimate being.

Gaston Bachelard

Contents

List of Illustrations

Preface

My largest task in this essay is to describe how consciousness and the chamber of being—those twinned and inner spaces of Vermeer's art—evolve throughout the course of an *oeuvre*. For these chambers are enclaves of being which embody the evolving consciousness of his personae: an evolution which extends from the representation of unfallenness and wholeness to anxiety and distress at the impingement of the outer world. Nor is this subject new to Northern painting. The birth of consciousness, for example, is precisely the point at which van Eyck discriminates between the *Lucca Madonna* and the *Ince Hall Madonna*. The Christ child's discovery of the world expresses itself as a detachment from the maternal breast and a curiosity (however bookish) about images. In the light of that discovery the Virgin's chapel expands, and her canopy, once dark green and brown, turns bright green and gold. As an interiorist, van Eyck is obviously Vermeer's truest antecedent. What is perhaps less obvious is that he anticipates Vermeer as an analyst of consciousness, for the transactions I discuss are as amenable to sacred garb as to secular. One might well do with the earlier artist what I have attempted with the later.

Proceeding, then, in roughly chronological sequence, this study traces the manner in which Vermeer constructs the essential metaphor of his art: the space of a bourgeois chamber, and the alienating consequences of its dismantlement. Constructing and dismantling what Gaston Bachelard in another context calls an oneiric architecture, Vermeer represents a mythology of consciousness which, beneath the difference of their ostensible subjects, links his paintings each to each.

In fact, we have just thirty-five paintings (one doubts there were ever many more), and it is not mere politeness to say that each is worthy of study: one does not, after all, regard every Rembrandt as a powerful distillate. So it is on the paintings I concentrate, though I try to give some sense of the socio-historical matrix in which they emerged. I take my task, as best I know, to say what these paintings mean, how they do work, and how they shape an *oeuvre*.

I am grateful to the following colleagues and friends for reading my text and helping me with their suggestions and advice: Lionel Abel, Charles Altieri, Hinke and John Boot, Barbara Jarocki, Emanuele Licastro, Neil Schmitz,

Donna Sheinberg, Alan Spiegel, and Howard Wolf. I am also grateful to Peter Parshall for commenting extensively on the first chapter. Most of all, I am grateful to Carl Dennis for continually challenging me to rethink my argument; and to Robert and Peggy Boyers, Editor-in-Chief and Executive Editor of *Salmagundi,* who gave me the opportunity of publishing an anthology of Vermeer criticism in their magazine (Spring/Summer 1979), in which the first chapter of this present study appeared in an earlier version.

<div align="right">Martin Pops</div>

Acknowledgments

I wish to thank the following museums and other holders of copyrights for their permission to reproduce the following works of art (all by Vermeer, except where otherwise noted):

The Frick Collection, New York: *Soldier and Laughing Girl, Girl Interrupted at Her Music, Lady Receiving a Letter from Her Maid* (Copyright The Frick Collection, New York)

Mauritshuis, The Hague: *Diana and Her Companions, View of Delft, Young Girl with a Pearl Ear-Drop*

Staatliche Kunstsammlungen, Dresden: *Procuress, Woman Reading at a Window*

Gemäldegalerie, Staatliche Museen Preussischer Kulturbesitz Berlin (West): *Girl Drinking with a Gentleman, Young Lady with a Necklace*

Collection Sir Alfred Beit, Bart., Blessington, Ireland: *Lady Writing a Letter*

National Gallery of Art, Washington, D.C.: *Lady Weighing Gold (Woman Holding a Balance)* (Widener Collection), *Girl with a Flute* (Widener Collection), *Girl with a Red Hat* (Andrew W. Mellon Collection), *Lady Writing a Letter* (Gift of Harry Waldron Havemeyer and Horace Havemeyer, Jr., in memory of their father, Horace Havemeyer, 1962)

Isabella Stewart Gardner Museum, Boston: *Concert*

Kenwood House, London: *Lady with a Guitar* (The Greater London Council as Trustees of the Iveagh Bequest, Kenwood)

Rijksmuseum, Amsterdam: *Maidservant Pouring Milk, Little Street, Woman in Blue, Love Letter*

Städelsches Kunstinstitut, Frankfurt: *Geographer*

Buckingham Palace, H.M. The Queen, London: *Music Lesson* (Copyright Reserved)

The Louvre, Paris: *Lacemaker, Astronomer*

Kunsthistorisches Museum, Vienna: *Painter in His Studio*

National Gallery of Scotland, Edinburgh: *Christ in the House of Mary and Martha*

National Gallery, London: *Lady Standing at the Virginals, Lady Seated at the Virginals* (Reproduced by courtesy of the Trustees, The National Gallery, London)

Herzog Anton Ulrich-Museum, Brunswick: *Couple with a Wine Glass*

The Metropolitan Museum of Art, New York: *Girl Asleep at a Table* (Bequest of Benjamin Altman, 1913), *Woman with a Water-jug* (Gift of Henry G. Marquand, 1889), *Lady with a Lute* (Bequest of Collis P. Huntington, 1900), *Allegory of the New Testament* (Bequest of Michael Friedsam, 1931, The Friedsam Collection), *Head of a Young Woman* (Gift of Mr. and Mrs. Charles Wrightsman, 1979), *Mérode Altarpiece* by The Master of Flémalle (Purchase, The Cloisters Collection) (All rights reserved, The Metropolitan Museum of Art)

Euro Color Cards, Sleeuwijk, The Netherlands: *Tomb of Prince William the Silent* by Hendrik de Keyser

Rijksmuseum, Utrecht: *Annunciation* of the *Middelrijns Altarpiece*

Museum of Modern Art, New York: *Girl Before a Mirror* by Picasso (1932), Oil on Canvas, 64 × 51 1/4" (Gift of Mrs. Simon Guggenheim) (Collection, The Museum of Modern Art, New York)

I also wish to thank the Committee of the Julian Park Fund of the State University of New York at Buffalo for helping defray the costs attendant upon this project: the purchase of photographs and the permission to reproduce them.

1

Childhood and the Oneiric House

As for Vermeer of Delft, Odette asked whether he had been made to suffer by a woman, if it was a woman that had inspired him and once Swann had told her that no one knew, she had lost all interest in that painter.

Marcel Proust

Vermeer was born in 1632, married in 1653, and died in 1675. He was a Catholic sympathizer or convert, the father of at least twelve children, and a life-long resident of Delft. He belonged to the painters' guild (but never studied in Italy), dealt in works of art, and died in debt. We know little else about him, and nothing of an intimate nature. We have neither portrait, nor self-portrait, nor drawings, nor letters. We do not know, in the sense Odette wants to know, whether he suffered for or was inspired by a woman. We have neither legends of romance nor intimations of *la vie bohème*. We have just thirty-five paintings.[1]

Twenty-one of these were sold at auction in Amsterdam in 1696, and the prices they fetched indicate that Vermeer had not yet lost his identity as a painter or his reputation. In the course of the next century he lost both: his *oeuvre* fell into scholarly neglect and critical disesteem. Some of his paintings were wrongly attributed, and others were falsely appropriated. The man who forged de Hooch's name to the *Painter in His Studio* had perhaps lost sight of the master. The man who overpainted the stained window in a *Girl Drinking with a Gentleman* had lost interest.

Our recovery of Vermeer dates from three essays Théophile Thoré published in 1866.[2] Thoré recognized the contour of a career and established the possibility of an apotheosis. Ruskin said the *Two Courtesans* by Carpaccio was "the best picture in the world." Aldous Huxley said the *Resurrection* by Piero was "the greatest picture in the world." (Connoisseurs sometimes delight in a stenography of enthusiasm.) In 1902 Proust said the *View of Delft* was "the most beautiful picture in the world."

Swann, who is writing an essay on Vermeer, might have charmed Odette with this tale of rebirth. Or he might have moved her with the romance of Rembrandt and Saskia. Rembrandt, of course, is a master of self-revelation, and we can easily imagine a criticism geared to an autobiography of archetypes:

the Prodigal Son, Death and the Maiden, Dark Night of the Soul, the Old Wise Man. Vermeer is still the "sphinx" Thoré called him, and though we have not discovered his secrets, it has not been for want of effort. Critics have tried to identify him, his wife, some of his children, and even his mother-in-law in his paintings. Such speculation is innocuous, inevitable, and flows from simple misjudgment. It supposes you can notate Vermeer's art on the basis of his life in a simple and precise way, almost as if the paintings were autographic. Malraux has gone to the greatest length in this respect—in search of a chronology—and made the biggest mess.[3]

A second kind of speculation is more sinister and flows from perverse enchantment. It supposes you can notate Vermeer's life on the basis of his art. For example: Vermeer was "a deaf-mute painter perhaps, almost an idiot in the lack of any of the mental furniture that normally clutters the passage between eye and hand, a walking retina drilled like a machine."[4] It is hard to think of a nastier compliment. For another example: "And that room he depicts, crowded with chairs, may it not be the refuge where Vermeer, a cripple, could move about and live almost comfortably?"[5] Was Vermeer defective? "Are we to see in Vermeer an artist of complete optical objectivity, or the Lautrec syndrome—a maimed painter, who because of his personal problem withdrew behind his camera cabinet [i.e., his *camera obscura*] to observe the ladies of his household?"[6] Needless to say, the use of the language of illness to explain the product of genius reveals the critic's hand, not the artist's.

That Vermeer was seriously infirm is untestably suppositious and seemingly absurd. That he fathered twelve children is scarcely more credible yet undeniably true. But if we did not know, could we have guessed? In other words, do the paintings tell us anything about paternity? "There are no children in Vermeer."[7] But arguing that he did not paint children because he had so many is like arguing that he painted percepts because he was a deaf-mute or chairs because he was a cripple. Besides, there *are* children in Vermeer—though not always of a customary kind. There is the trans-human Cupid figured at full length in two paintings within paintings, immobilized in art. There is the prehuman fetus, the unborn child immobilized in flesh. Three women are conspicuously pregnant. And there are two playmates on their hands and knees in the *Little Street* who exist as much for formal design as narrative occasion: their bodies shape an angle in consonance with a bench beside them, and we cannot see their faces. They are immobilized in play.

Vermeer's rule for children seems to be: exclude them if you can, include them if you must. But this exclusion has nothing to do with paternity and everything to do with picture-making. Rembrandt once declared a baroque desire for "the greatest and most natural *beweechgelickheyt*" (outward motion or inward emotion).[8] Vermeer cherishes the immobility of his models. They do nothing more flamboyant than two hands allow: they pour milk, play music, make lace, write letters. A lady sighs, another stares, but no one solicits our

attention. The calibration of these interiors is so fine that modest laughter may discompose them and us.[9] What place is there in them for tykes and Holy Babes, magnets of sentiment? Kids and Cupids induce that reflex of desire which urges us to possess them as they attract us. These paintings, however, do not urge themselves upon us at all. Vermeer satisfies our demand for verbs of action—the requisite of a narrow realism—but he cares as much about states of being.

"In a typical Dutch house of this period [in Rembrandt's Amsterdam] no two rooms were at the same level, and going from one room to another involved climbing up or down stairs."[10] If we consult the work of Vermeer's colleague Pieter de Hooch we find such stairs. We never find them in Vermeer, who resists an architecture of dispersion as he resists children. Vermeer concentrates space in corners. He is a literalist of the imagination, who uses a bourgeois interior for analyzing the soul. Claudel has a wonderful phrase for these intimate scenes: "they are the container of an evaporating sentiment."[11] We have sixteen paintings of a person alone in the corner of a room.

In the seventeenth century Delft was girt by water and walls. A contemporary (1649) map (fig. 1) sharply distinguishes between the inner space of the town and the outer space of the countryside, between the inner space of Market Square (the center of civic and sacred power) and the town which surrounds it. Delft is a labyrinth at the center of which is a temple. The Vermeer house—called Mechelen—fronted the Square at this boundary between spaces.

Vermeer may well have painted the Mechelen Swillens reconstructs, but his paintings also disclose another house not found on any map.[12] Its plan and elevation obey the law of another architecture, and Swillens's drawings will not help us reconstruct it. "Before he is 'cast into the world,'" writes Gaston Bachelard, "man is laid in the cradle of the house,"[13] and until he is cast into the world, this cradle is his retreat and private shelter. Mechelen is the armature of this other space, the cradle of dream-memory below a time Bachelard calls "oneiric." Vermeer transcends the coordinates of rational architecture, and Bachelard will help us reconstruct this other dwelling.

The people who belong to it belong to a counterworld as absolute as a mirror-image. Is Catherina Vermeer among them? (It is impossible, after all, that she did not sit for her husband.) If we mean, Is there a woman who looks like Catherina in these paintings, the answer is doubtless yes, though who she is we cannot say. But if we mean, Is there a woman who is Catherina as Saskia is Saskia (Rembrandt's wife whatever the costume), the answer is doubtless no. And as for the children. . . . Let us simply say that a schedule of pregnancies will not help us. We want a schedule for lying in and casting forth from a different cradle, and we won't find it among baptismal records. These paintings will not tell us anything about paternity because they face in another direction. They are more about childhood than children.

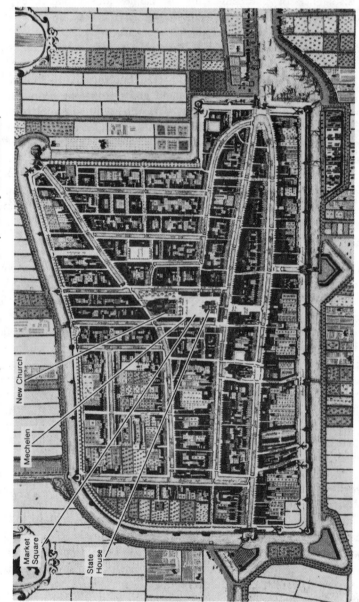

Fig. 1. Detail of a Map of Delft (Willem Blaeu, *City Atlas of the Netherlands*)

The *Woman Reading at a Window* (fig. 2) will serve as our point of departure. The woman in it is more formidably barricaded than anyone else in the *oeuvre*. Her corner is an enclave, and Vermeer denies its merely quotidian aspect. What Berenson says of space-composition in general is particularly true of this painting: "it humanizes the void, making of it an enclosed Eden."[14] In the dialectic of inside and outside, being is on the inside. "The corner is the chamber of being."[15] The woman reads a letter from without which draws her further within.

This painting is Vermeer's first essay on reflection. The woman who reads generates a second self, the woman absorbed in what she reads. In the act of reading, the reader is doubled: one self inhabits the sensuous world, the other a transparent reach beyond the bars of the reflecting glass. The self which migrates into the world of the text is seduced by language and held captive.

Since the late Dugento the Virgin had been represented on innumerable occasions with an opened prayer book. Had she been reading the Good News in *Isaiah*—"Behold a virgin shall conceive" as the Pseudo-Bonaventura suggests—even as Gabriel delivered his announcement?[16] In Vermeer the messenger is never an angel: he is a soldier, a courtier, or a gentleman-caller, though sometimes—as in our painting—all that remains of him is his message, the letter the lady reads. How did she get that letter? It must have flown in through the window.

The Virgin's book is the attribute of her interiority. Reading is a type of parthenogenetic fertilization, magic doubling: the woman reading gives birth to her own second self. Do we doubt she reads of pure and serious love, or that, like Mary, she is as fresh and intact as the fruit inside the bowl? "The fruit," notes Panofsky of van Eyck's *Melbourne Madonna,* "beautifully fresh and intact, suggests by this very intactness the *gaudia Paradisi* lost through the Fall of Man but regained, as it were, through Mary, the 'new Eve.'"[17] Christ is the perfect fruit of her womb even as the fruit of our painting is womblike (except for the half-eaten peach). Vermeer constructs a dialectic of spaces in small no less than in large: the imperfect peach lies conspicuously outside the bowl.

Vermeer melodramatizes the schema of the Annunciation not only by the wide-open window and the woman smitten by sunlight but by the moveable curtain. There is, to be sure, a tradition of deceptive curtain painting in secular Dutch art of the seventeenth century,[18] but there is an older and more important tradition in religious art, as represented by Giotto's *Annunciation* at Padua, in which a curtain attached by links to a rod defines the space of the Virgin's chapel. In fact, Ludwig Goldscheider argues that "the composition of the [*Woman Reading*] is derived from those of the Virgin in the chamber, the Virgin of the Annunciation," and he cites chapel curtains in Crivelli and Grünewald as evidence.[19] In the bourgeois interior the moveable curtain defines the *thalamus Virginis,* as in the *Columba Annunciation* of Rogier van der Weyden. We may suppose Vermeer was aware of this tradition, too.

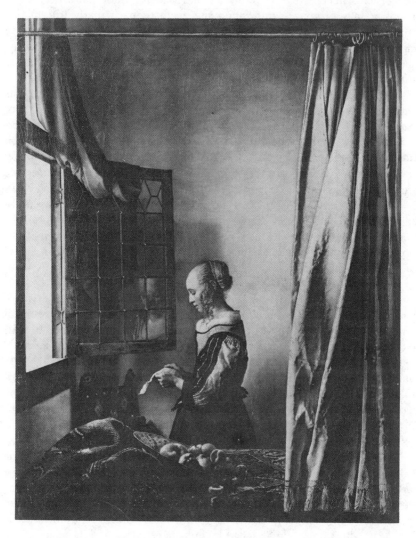

Fig. 2. *Women Reading at a Window*

"In the oneiric house," writes Bachelard, "topoanalysis only knows how to count to three or four": a vault or cellar (to which we always descend), a tower or attic (to which we always ascend), and one or two stories between (in which we live our daily lives).[20] The cellar "is first and foremost the *dark entity* of the house, the one that partakes of subterranean forces."[21] The *Procuress* (1656) (fig. 11) is the one painting in the *oeuvre* at once sexually explicit and not lit by natural light. It is the only one in which figures crowd the upper edge of the canvas, as if the ceiling of the space they occupy were itself low—as if the space itself were a cellar. In contrast, the *Woman Reading* provides more space above the figure than any other (it is the one Vermeer with a pronounced vertical format), and the woman in that burst of light seems isolated in an upper storey. At the furthest remove from the bawdy procuress, she reminds us of an Annunciata even as her corner reminds us of Danaë's tower.[22] The *Procuress* and the *Woman Reading,* early and explorative, define the polarity of oneiric architecture.

The *Woman Reading* glows with unearthly clarity, otherworldly sheen: brilliant and pristine. But what other world? This painting seems to me a daydream of ideal refuge, an annunciation of space and light. Vermeer encloses his persona in a sanctum of silence and slow time, a space below time. She is a concentrate of spirituality, as motionless as the memory of childhood. When Claudel comes to Vermeer, he lapses into English: "s'il faillait d'autres adjectifs, ce seraient ceux qu'une autre langue seule nous fournit, 'eery,' 'uncanny.'"[23] Vermeer's window is a magic casement, and Claudel needs another language to speak of that other world.

As I stands before a mirror, the figure before me belongs to a world inconceivably silent, inviolably remote; a realm of inaccessibility and reversal. The *Woman Reading* teaches a simple lesson in this metaphysic. The figure behind the bars of the glass is in the fastness of her secrecy, full-face instead of profile. She is painted according to laws of reflection which Vermeer's contemporaries either did not know or did not choose to follow. That is why she is smaller than the figure which reflects her. She is also out of focus, as if her image were "formed by a lens in an optical device focused on the plane of the mirror."[24] Vermeer doubtless observed her in a *camera obscura* (fig. 3). The artist in the fastness of his secrecy encounters an inviolable image in his mirror. We encounter the inviolable time of childhood and the inner space of that mirror in this painting.

The *Woman Reading* is a work of great bravado, a silver penny which certainly impresses us with its glow and dazzle, and it will hardly do to fault a work which offers so much pleasure. Yet who will not recognize a young man at the mercy of his means? Extending a curtain and massing a carpet, Vermeer overdetermines his foreground plane in eagerness to define an inner space. He encourages us to encircle his figure, but his arc of encirclement smacks of manipulation (fig. 4).

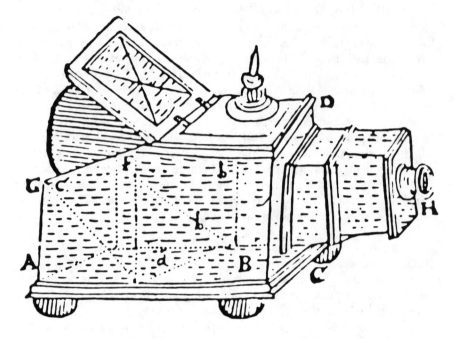

Fig. 3. *Camera Obscura* (R. Zahn, *Oculus Artificialis*). This seventeenth century *camera obscura,* a portable table model, includes adjustable lens, angled mirror, and translucent screen. The lens rights the image, which would otherwise remain inverted, but does not reverse it, even as Vermeer's paintings preserve about themselves a sense of original otherness.

The bowl of fruit which curves into the serration of drapery is speciously propped, and the large forms which frame the figure—curtain, table, and window—are a trifle declamatory. Nevertheless, these defects of depth and plane may not become visible until we compare the *Woman Reading* with the *Woman with a Water-jug* in which similar problems are resolved with perfect assurance.

In a famous metaphor, Alberti compared the rectangular edge of a painting with an open window: the artist looks through the window at his subject. The virtue of perspective is that he may record what he sees in the convincement of depth. The burden of perspective is a neglect of the picture—plane such convincement may entail. I am not saying anything either the first master of Renaissance space (van Eyck) did not understand and the last master (Cézanne) did not suffer. Like them, Vermeer learns how to satisfy discrepant urgencies, to excavate space yet valorize surface. The *Woman with a Water-jug* offers an elegant solution to a problem neither a walking retina nor even a little master could be expected to set (fig. 5).

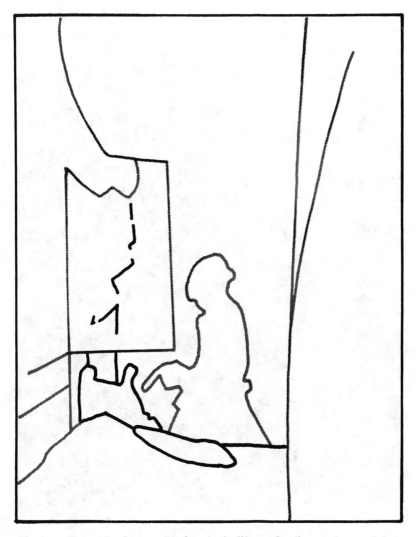

Fig. 4. *Woman Reading at a Window*. As the Woman Reading stands toward the
light, we follow Vermeer's arc of prospective encirclement toward (and past)
the open window.

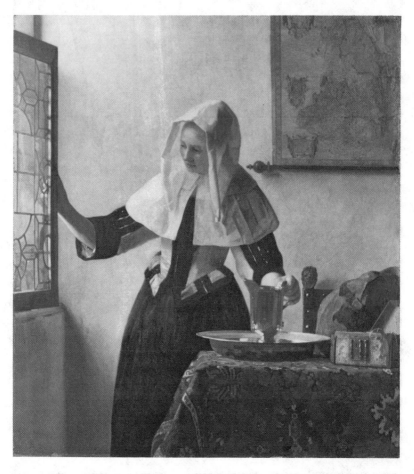

Fig. 5. *Woman with a Water-jug* (ca. 1663-65)

At first glance, we see a woman in a corner. There is a table with objects in front of her, a map and chair behind, an angled window and wall to one side. Space is differentiated into planes and the indices of perspective agree: a woman is standing in a corner. Her shy turning directs us toward the light. If we follow the gentle thrust of objects, we may encircle her (fig. 6).

On closer inspection, however, we notice one point at which the woman and a nearer plane of the painting seem to merge—at her left arm and the spout of the pitcher—and three points at which the woman and deeper planes seem to converge—at her left fist and the edge of the chair, her left shoulder and the bobbin of the map-stick, her right cuff and the shadow of a lion's head (fig. 7). How shall we account for these odd convergences?

"In modern design ," wrote Philip Hale in 1913, "it is almost an axiom that two marked forms in different planes of the composition should either overlap or be quite widely separated. Bringing them close together as Vermeer has done is often spoken of to students as a fault."[25] Hale noticed the nearness of the woman's shoulder to the mapstick; and although he thought Vermeer had successfully violated a principle of academic instruction, he had no idea why Vermeer had challenged it in the first place. Indeed, why had he?

There is an optical ambiguity at the point where "marked forms in different planes" meet—the perspectival space between these forms seems to dissolve. By availing himself of this ambiguity, Vermeer compresses the depth of the corner and jeopardizes its stability as an enclosure. Furthermore, if we compose our points of convergence into a triangle and focus at its center—the virtual center of the painting—we must see the large but undeclamatory forms which frame the figure (map, table, and window) in peripheral vision. And when we see them peripherally, the corner they define flattens. They valorize the plane in an equipoise of joinery, the woman at their center neatly fitted among them. *Vermeer affirms and subverts the indices of perspective in the same painting.* The Woman with a Water-jug is in yet out of a corner. Her being-in-the-world is as hesitant and tentative as the sesame of our perception.

The woman whose body joins the window-catch to the water-jug embodies "half-open being."[26] She is like the half-open window. The more it opens, the less it discloses. Her opened stance mocks us with the paradox of meaning, tempts us with secrets we can never know. The panes of glass, like planes in a cubist painting, recede or advance as we regard them. The woman is as incommensurable as the corner, as ambiguous as the glass, as opaque as the vessels. The water-jug, the jewel-box, and the basin are "houses for things," enclaves of privacy. We see the outside of vessels but not inside them; we see inside rooms but not outside them. This painting is empty of icons but filled with a reticence of being.

The first definitive portrayal of the Annunciation in a bourgeois interior is the *Mérode Altarpiece* (ca. 1425)[27] (fig. 8). The Master of Flémalle portrays Gabriel and the Virgin but conceals other aspects of the supernatural "under

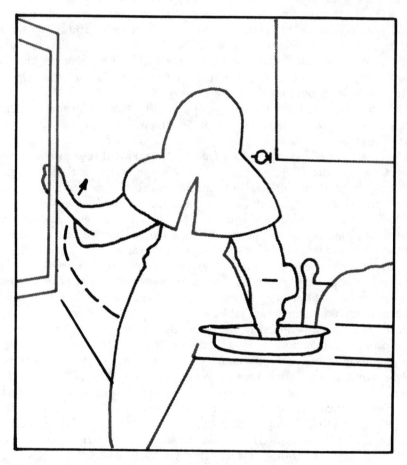

Fig. 6. *Woman with a Water-jug*. Our eye is drawn across the woman toward the light, then under and behind the sunlit portion of her forearm, as indicated by the broken arrow. (I have emphasized a shadow line on the wall.)

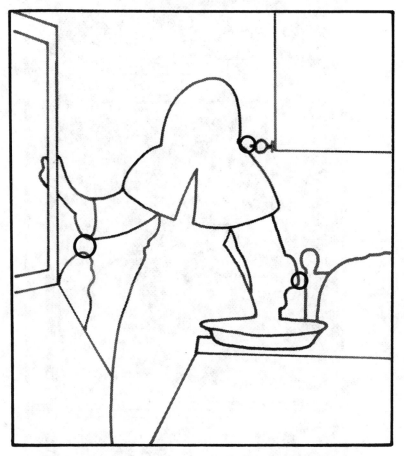

Fig. 7. *Woman with a Water-jug.* Three points of unexpected convergence.
(I have outlined the shadow of the lion's head on the wall.)

Fig. 8. The Master of Flémalle, *Mérode Altarpiece*

the cloak of real things"—the candle, for instance, which signifies Christ or the candlestick which signifies His mother.[28] This allegory of objects, which means to reconcile the dogma of Christianity with the new naturalism of the Renaissance, is "rooted in the conviction that physical objects are, to quote St. Thomas Aquinas (*Summa Theologiae...*) 'corporeal metaphors of things spiritual.'"[29] The *Woman with a Water-jug* is not an allegory, and the woman herself is not the Virgin, although there lingers about this painting that Thomistic assertion, as if a painter of Catholic faith and conservative temper might still draw sustenance from it. As in the *Woman Reading,* a sacred archetype underpins a secular anecdote.

The tidy young woman in blue and yellow is a timid recipient of light, a demythologized Annunciata. Vermeer surrounds her with Marian attributes. The water-jug and basin recall the ewer and basin in the *Werl Altarpiece* by The Master of Flémalle and the *Louvre Annunciation* by Rogier van der Weyden: they are typically coupled symbols of Marian purity.[30] The sculptured lion's head on the chair recalls the sculptured lions on Mary's bench in the *Mérode Altarpiece* and on her throne in the *Lucca Madonna* by Jan van Eyck: they are symbols of the lion-flanked Throne of Solomon, the Madonna as *Sedes Sapientiae.* The table-carpet recalls those rich floral canopies for the Virgin in the *Melbourne, Paele, Dresden,* and *Lucca Madonnas:* they are translations into art of her enclosed garden, symbols of Marian chastity and sacred space. Butterflies, beetles, birds, and flowers adorn her carpet which also functions as a partial enclosure. The strand of pearls over the edge of the jewel-box recalls the string of white rosary beads over the edge of the Virgin's coffer in an *Annunciation* (ca. 1410) by an anonymous master in the museum at Utrecht (fig. 9).

In the central panel of the *Mérode Altarpiece* and in the *Woman with a Water-jug,* sunlight illumines a woman through windows at her right. In The Master of Flémalle this light signifies the "new light" of the Christian Dispensation, the window "illuminating grace," the Virgin's right the "right" side—her left is the "sinister." In Vermeer these interpretations do not apply: our painting is an evocation of piety, not an allegory of love.

There is, then, in the *Woman with a Water-jug* a confluence between the maturation of private means and the adaptation of traditional matter. But there is also an iconographic conversion which Vermeer practices upon his own earlier painting, *Diana and Her Companions.* Vermeer converts a paralysis of natural forms into the stillness of still life (fig. 10).

The only living animal in the *oeuvre* is Diana's dog who, despite his reputation for ferocity, sits tamely and silently.[31] (The myth is Greek but the dog is Flemish.) Translated into art, he becomes a sculptured lion's head, a warder of silence. The only living plant in the *oeuvre*—scrawny and without flowers—is also in the *Diana;* translated into art, it becomes the red, blue, and yellow petals of the tapestried garden. There is no living bird in the *oeuvre,* but

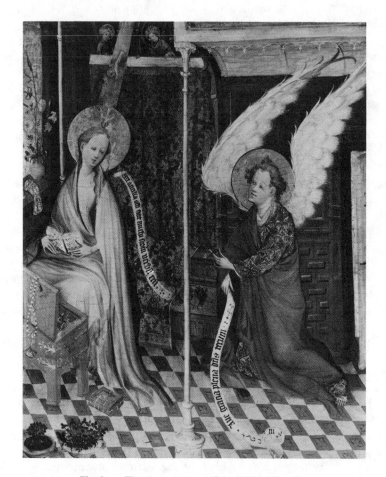

Fig. 9. The *Annunciation* of the *Middelrijns Altar*

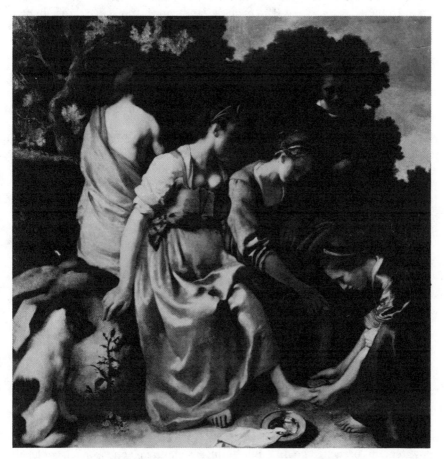

Fig. 10. *Diana and Her Companions* (1657-59)

the only apparently live one is in the *Diana.* A crumpled towel, as Pierre Descargues observes, "seems to assume the shape of a dove drinking from the basin."[32] This "dove" displays none of the vitality of the tapestried bird, wings outspread, who alights on the tapestried flower. The only landscape in the *oeuvre* (not counting the special case of paintings within paintings) is also in the *Diana:* an uncertain rock, a turbid unreal tree, and the crown of an anonymous forest. In the *Woman with a Water-jug* the landscape is translated into a map, which is a more accurate notation of the land, and, perhaps, a more lively intimation of it as well: the great beetle in the tapestry and the cartouche in the map directly above it are inverse images of one another. The *Woman with a Water-jug* glories in a richness of cultural constraint. The dreamer of inner spaces (in a rainbow of leaded glass) suppresses the world.

"The first task of an anthropology of the imagination is to make outside vast and inside concrete."[33] In the *Woman with a Water-jug* Vermeer triumphs by means of paradox and indirection. Inside is concrete because it is incommensurable; outside is vast because it is invisible. Vermeer fails in the *Diana* because he proceeds literally—never mind his debt to Jacob van Loo. He makes outside vast but not credible: that landscape is neither felt nor seen. He makes inside concrete but not intimate: we see the bottom of the water basin. There are twenty-seven opaque vessels in Vermeer—jugs and pitchers, basins, boxes, bowls, and baskets—but we seen the bottom of only this one. "The oneirically definitive house'" (or "house for things") "must retain its shadows" or forfeit its reason for being.[34] These vessels enclose an acoustic space rather than a visual one, a space we can sound but cannot see.

Vermeer's misplaced concreteness suggests that the *Diana* is a painting in which "the artist [has] not yet arrived at a coherent idea of what he [is] aiming at."[35] Consider, too, the crypto-Christianity of his pagan subject. The acolyte who washes the feet of the goddess performs a task of Christian humility. The towel and the basin are often symbols of Marian purity, the "dove" of the Holy Spirit. But Vermeer makes a naive pun of the "dove," not an allegory of the supernatural "under the cloak of real things."

The *Diana* is Vermeer's most sensuous painting—*luxe, calme, et volupté*—and we can say of Diana's dress what Fromentin says of Rembrandt's palette: "if it were analyzed, there would be discovered in it, like a magnificent alloy, remains of melted gold."[36] But Vermeer's mature palette is much cooler: "crushed pearls" or, as in the *Woman with a Water-jug,* a pearly substrate.[37] Vermeer renounces *Diana,* dim and Venetian lustre. He exchanges dusky gold for lemon yellow. At bottom he is a connoisseur, not a voluptuary.

The six figures of the *Diana,* near the foreground in cross-axial alignment, are static and ornamental, as if they belonged to some magnificently encrusted brooch or relic. They absorb our attention and we are not invited to an exploration of deeper space. Of the early paintings only the *Procuress* can lay larger claim to frontality (fig. 11). Its structure—four figures in a row—is more

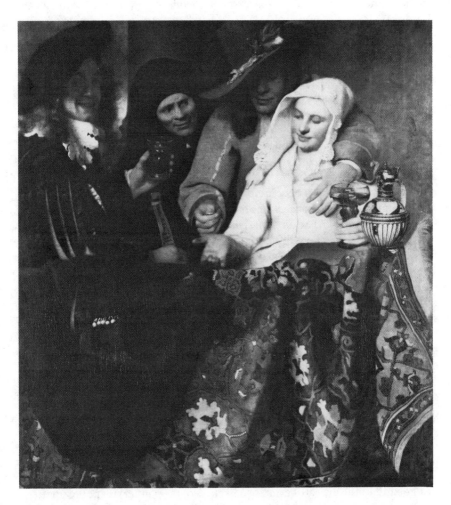

Fig. 11. *Procuress* (1656)

primitive than the *Diana's,* its appropriation of the picture plane more emphatic. Vermeer's father had kept a tavern in Mechelen, but Vermeer merely locates his scene in a dark and indefinite space, in what seems to be a cellar. In any event, the *Procuress* is not a reminiscence of love but a conjunction of motifs. Vermeer joins a merry musician—someone like the fellow in Gerrit van Honthorst's *Merry Violinist* (1623)—to a bawd, prostitute, and cavalier, a trio we find in a painting Vermeer owned, Theodor van Baburen's *Procuress* (ca. 1622). The jointure, however, is imperfect: as Charles Seymour observes, we look up at the musician but down at the prostitute.[38]

Furthermore, the musician is outside the scene he witnesses: the edge of a wall and the incipience of candlelight separate him from the others. But he is also inside it, for Vermeer secretly associates him with the prostitute. A glass of wine in his left hand extends from a black-and-white ribbed doublet; a goblet of wine in hers emerges from a blue-and-white ribbed jug. Each wears lace filigree. Her right hand is cupped open—she is a complaisant receptacle for the cavalier and his coin. His right hand is closed upon his upright instrument, and he regards us with a plenum of consciousness his smile does not excuse. By raising his instrument, he reciprocates a public transaction in sex with a private one at which he hints, masturbation. By raising his glass, he celebrates venal love. But how can he celebrate venality without serving it? No less than the prostitute, whose gentle eye cannot conceal her practiced hand, he knows what he is about. The subject of this painting, after all, is prostitution.

The musician is in the game and out of it, a complicated figure who smiles through his complicity. Vermeer characterizes the bawd and the cavalier with simplifying extravagance, but the prostitute, like the musician, is ambiguously rendered. Renoir once noted her seemingly honorable air, and she and the procuress do seem moral complements. Like the dainty musician and the virile cavalier, they seem paired in the symmetry of nature or dream.

Vermeer's conjunction of motifs survives in this dim and amorphous space: as if it had been dreamt and uneasily held. The motifs themselves dissolve in the light of day. All that remains of the bawdy world are two imitations of Baburen's *Procuress,* paintings within paintings. All that remains of the complicitous musician is his costume, which the Painter in His Studio inherits.

The *Procuress* is the autobiography of an idea, but whether we may read it as a portrait of the artist (or even for a likeness of the painter) is another matter. Vermeer's usual strategy is more opaque. Rembrandt studies the self in a mirror; Vermeer observes the personae of the self in the angled glass of a *camera obscura.* There is no evidence that the musician is a likeness of the painter, but if he is, then his relation to the prostitute gains new point. It implies that self-portraiture courts self-indulgence, that beneath the congratulatory presentation of self lies a prostitution in spirit which Vermeer would ever after avoid.

Self-indulgence, in fact, is the sly sub-text of the *Girl Asleep at a Table,* the "dronke Slapende Meyd aen een Tafel" of the 1696 auction, though it is a little hard nowadays to tell she is drunk (fig. 12). She seems as demure as the prostitute seems honorable. The disorder of her table (and her collar) is "discreet";[39] Vermeer hides her wineglass against the tablecloth. She is barricaded by divergent planes but not encapsuled, and a quite violent diagonal enforces her acentricity (fig. 13).

Unlike the Woman Reading, the Girl Asleep is not at the center of her canvas or cosmos. At the four corners of the painting objects flee from her. In the foreground a fallen bottle empties to the left and a lion's-head chair (unexpectedly) faces to the front-right. In the middle-ground the fragment of a painting leads us outward to the left and the margin of a map directs us to the right. In the background a second room seems to issue from the first. These details suggest both the centrifugal impulse of the sleeper's mind and a diffusion of the being of the room. Sleeping generates a space of multiple extension: a labyrinth, not a temple.

Light which illumines the girl from her "sinister" side also illumines a wine-pitcher whose handle is raised like an arm to a black stopper on which four facets are reflected. A ridge and three slashes of paint indicate eyes and a mouth, a triangle indicates the nose, and we realize that sleep has spawned (has spontaneously generated) a demonic self beneath the mask of a placid face. Dreaming is another kind of magic doubling: the pitcher is a projection of another, a nether, self. It is a mirror-image less cunning than the windowpane but an object-lesson more cunning than the water basin. We learn the dreamer's burden from the painting behind her. Cupid's leg and discarded mask suggest a disinterment of desire at once repressed in the pale light of a lower storey.

The dreamer faces us in a mask of self-possession even as the diagonal (which divides the painting) isolates her from the plain geometry of her rooms. Asleep, she presides over the sensory indulgence of her table. The plump and glossy fruit, the sheen of faience, the motley mantling of carpet: Dutch Realism fulfils itself in an amplitude of textural definition. But as a caution, perhaps, against self-indulgence it fulfils itself in a dreamer's space.

The only dissonant element of that space is the anthropomorphic pitcher, for it is not an adequate metaphor of the dreamer's bodily being. Vermeer's lapse into a pathetic fallacy is as unsophisticated as his equation of towel and "dove," musician and prostitute. These are apprentice ways of coding information, whereas the *Soldier and Laughing Girl,* like the *Woman Reading,* is a discourse on method in which Vermeer constructs a metaphoric enclosure for the first time (fig. 14).

In fact, he constructs an anatomical space, identifying the girl's sexual self with the geography of a bourgeois interior—hence the channel of light which issues into the private recess of her room (fig. 15). She defends that recess as she defends her body: the *Soldier and Laughing Girl* is a witty defense of private

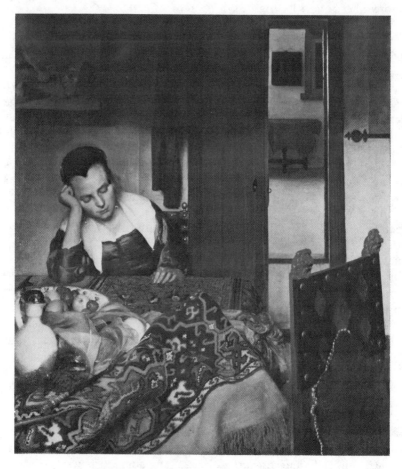

Fig. 12.　*Girl Asleep at a Table* (ca. 1657-59)

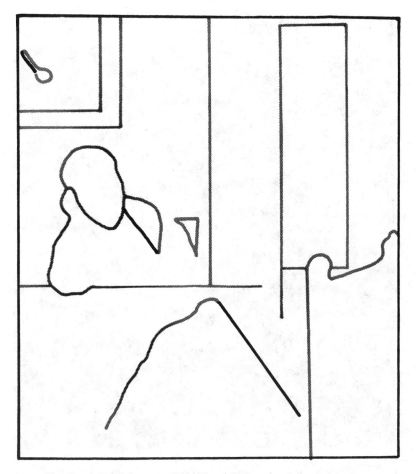

Fig. 13. *Girl Asleep at a Table*. The girl's acentric relation to her space.

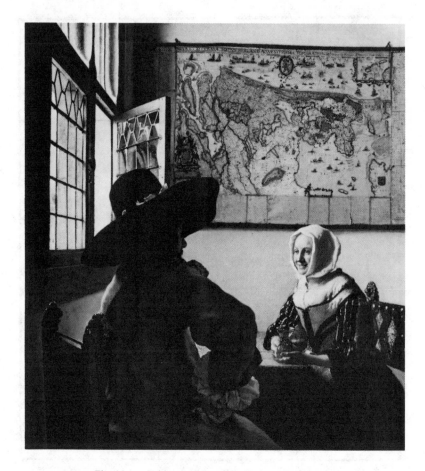

Fig. 14. *Soldier and Laughing Girl* (ca. 1657-59)

Fig. 15. *Soldier and Laughing Girl.* The crooked lane and the private recess.

property, though only the girl seems to get the joke. She is a flirt, and her gently uncupped hand forestalls as it invites. Her map admits all Holland and West Friesland, but will she admit her impatient courtier? Will looming darkness invade her sunlit corner? Having constructed a private enclave, Vermeer expends his most visible effort in assailing it.

The burden of that assault falls naturally to the Soldier, and Vermeer exploits a characteristic effect of the *camera obscura* in rendering him. A figure very near the lens of the *camera* will seem disproportionately large in comparison with a figure in the middle distance. Vermeer embraces this seeming disproportion (which the mind ordinarily fails to notice) to construct a figure of considerable menace. At the same time, by embracing a technique of optical objectivity, he advertises a superior realism. As in the *Woman Reading,* Vermeer reminds us that he already knows more and sees more clearly than any little master.

On several occasions Vermeer angles an empty chair along a foreground plane, and this chair (which acts as a *repoussoir)* gently introduces us to deeper space. In the *Soldier and Laughing Girl,* the chair is full and we are propelled forward along a powerful salient. In fact, the melodramatic thrust of the Soldier is equalled only by the melodramatic sweep of the map. An open window provides a third source of invasion, though it is only through an adjacent pane that a house reveals itself. The outer world jeopardizes the inner in this painting from three directions: front, back, and side.

The house, small and distant, suggests that the Laughing Girl occupies a second or middle storey, just as she occupies a middle space of dalliance between indulgence and chastity. Her smile is the index of triumphant play, and there is no other painting in the *oeuvre* of such vivacious charm. Thoré tells of a man who looked behind it in order to discover the source of its incandescence. Vermeer paints an innocent brightness, not the light of common day, even as he paints a space which, like the depth of an opaque vessel, still preserves its secrecy. This space is beyond sight and below time.

"Before he is 'cast into the world,' man is laid in the cradle of the house." And so I have begun with the Woman Reading who is turned within. She distances herself in the freedom of confinement as if another world did not exist beyond her window. Sexual sublimation is analogous to oneiric ascendance, and she seems to preserve an inviolateness prior to psychology. She reads unselfconsciously in an upper storey. An unconscious girl sleeps in a lower. One is centripetally cocooned, the other centrifugally dispersed, but each retreats from the world's attention. Only the Laughing Girl (in the paintings I have so far discussed) pursues the task of ego-consciousness: to meet the world at the threshold, to mediate between private space and public.

The Woman with a Water-jug is turning without. She is barely protected in a corner which—even now—disappears at a moment's notice. Soon we must

speak of loss, of being cast from the oneiric cradle. Vermeer constructs and dismantles a chamber of being, the presence or absence of which is nearly invariable in his mature work. He initiates and projects a mythology of consciousness. Consciousness and the chamber— those twinned and inner spaces—evolve dramatically throughout the course of his *oeuvre*. Their evolution is my longest subject.

2

Consciousness and the Chamber

A child's first perception of space is neither perspectival nor metrical, but topological. It is a perception not of measure but of various categories of relation: succession and enclosure, proximity and separation. The child not only separates himself from the world but separates the world from itself: at a very early age he discovers boundary and boundedness.[1] Vermeer compromises perspective and measurement (those adult instruments!) on behalf of these prior and childlike categories. In the *Woman Reading* he encloses an ontological space; in the *Woman with a Water-jug* he collapses that space before restoring it in the relaxation of an eye. He voids the chamber (of being), then fills it again. These paintings are not essays in the "rationalization of sight"[2] but are subversions of rationality too subtle to call Mannerist. Vermeer celebrates the ontology of the chamber, which is why the Woman in Blue interests us so much: she is herself the chamber he celebrates (fig. 16).

The pregnant woman is an unwobbling pivot, a "centralization of life guarded on every side."[3] Chairs and a jewel-box define the boundary of her encirclement, the circuit of living air in which she breathes and swells. We too may encircle her, though in a smaller circumference (fig. 17). In the *Astronomer* and *Geographer* Vermeer represents celestial and terrestrial globes, but the round world of which Bachelard speaks—"the world [which] is round around the round being"—is not a geometrical sphere.[4] Those globes are empty. The Woman in Blue is full. She is a chamber of being, enclosing an acoustic space as she inhabits one. She is a still point of enclosure and inhabitation, at once encircled and encircling. Her pregnancy suspends time in an equilibrium of opposites. The dialectic of inside and outside dissolves in her body. *She propagates her own roundness.*[5] Marian purity excludes a male presence, and reading is an unselfconscious exercise in parthenogenetic power. Enlarged in pregnancy, she reads a letter—like the Woman Reading who is doubled in the glass. Vermeer was the father of twelve children, but the *Woman in Blue* is a daydream of parthenogenesis.

Although this painting and the *Young Lady with a Necklace* are sometimes bracketed (as studies in pregnancy), there is in fact little sympathy between them (fig. 18). Composing a face in the glass is a conscious exercise in

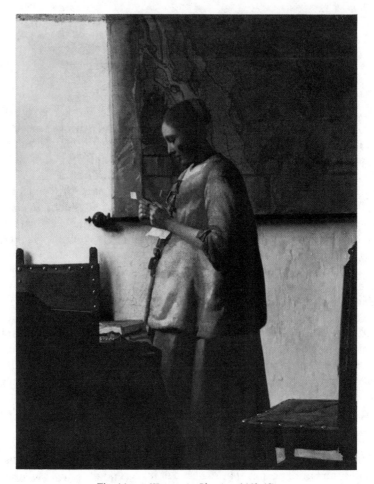

Fig. 16. *Woman in Blue* (ca. 1663-65)

Fig. 17. *Woman in Blue.* If we follow three edges (of the tablecloth, coat, and book) to the point at which they converge, we may propel ourselves around the figure.

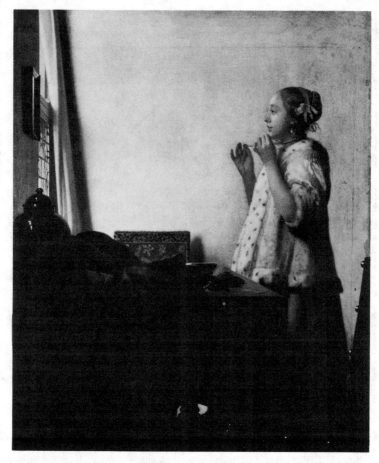

Fig. 18. *Young Lady with a Necklace* (ca. 1663-65)

narcissistic doubling. The pregnant Young Lady, who gazes upon the mirror of her adornment with an impassive eye, is a voyeur whose object of calculation and desire is herself. We appreciate the fineness of Vermeer's moral criticism as we compare her with the Woman in Blue whose svelte figure breathes an interior animation, whose neck and chin are shapely and incisive. The mapstick behind the Woman in Blue, the horizon of a sky-tinged wall, traverses the upper half of her body. The fetal burden of gravity seems resistible.

The spiritual grossness of the Young Lady with a Necklace reveals itself in her tentlike torso, the squatness of her oriental jar, and the earthen color and irresistible gravity of objects massed in the lower half of the painting. Nor is there counterweight on the wall above. The Young Lady is centered neither in herself nor, her space, and like the uncentered Girl Asleep, she is the victim of a *vanitas.* She is as attached to herself as her gaze to the glass: self-love completes itself in a mirror-image.

Chairs in the *Woman in Blue* are slender and simple, and one of them, penetrated by light, rises to an airy pinnacle. Those in the *Young Lady* are more stolid and ornate, and one of them is embellished with bulbous studs and a tassel. A thick and ponderous cloth abuts the oriental jar; a thin and protean cloth winds beneath the jewel-box. Subtlety lies in these discriminations and power in their sum. The Young Lady is as sealed as her lips, as sealed within herself as the oriental jar. Like the jewel-box, the lips of the Woman in Blue are open; they inhale the news as if inhalation were still an activity of the soul. How can we ever confuse these women?

Vermeer exposes Diana's feet and the feet of her dog, but he quickly learns to sublimate the lower and animal part. He practices concealment by skirts, furniture, and the very edge of paintings. He never exposes the foot (shod or unshod) of a secular woman in a bourgeois interior, and I raise this point not because (against all expectation) he displays the Young Lady's but because he displaces it into a tableleg. That thick tableleg is the very emblem of matter.

The *Young Lady* is a painting of satisfactory ordonnance, but the *Woman in Blue* is exquisite. Vermeer not only encircles his figure twice in depth, but he also establishes a rhythm of interval across the plane—chair, wall, figure, wall, chair—which composes a powerfully stable and enclosing shape (fig. 19). Vermeer does not offer us Vitruvian man glumly stretched to his circumference, but a woman of queenly cast—a *tertium quid* of natural harmony.

As the Woman Reading suggests an Annunciata and the Woman in Blue a Madonna del Parto, the Maidservant Pouring Milk suggests a Virgo Lactans (fig. 20). She pours milk from pitcher to pot with a seriousness we hardly understand. She bears such gentle relation to the vessel she holds that it is as if the milk were issuing from her own breast. She is a Magna Mater of nourishment and plenitude. We witness a mystery of vessels, a sacrament of bread and milk: we experience the solemnity of a religious event.

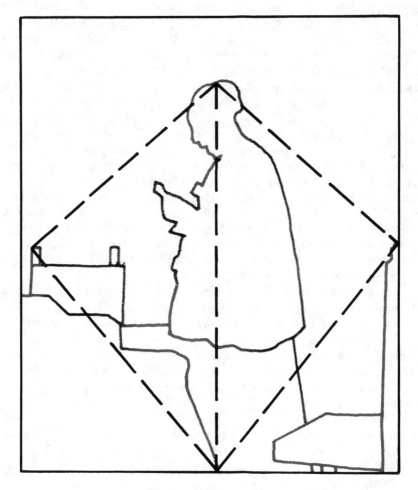

Fig. 19. *Woman in Blue*

The Maidservant is a proletarian, not a bourgeoise, and she wears neither pearls nor ermine. Though no necklace graces a jewel-box, a thousand jewel-points grace the loaves of her bread and basket. Vermeer spiritualizes matter. He transforms daily bread into wafers of light, a lowly milkmaid into a pearl of great price. In the absence of painting, map, or mirror on the wall, nails and nailholes comprise a coronal of use and suggest a constellation in the Milky Way.

The Woman in Blue is an armature of space, the Maidservant an armature of vessels. A metaphysic of solitude and secrecy accounts for a jug, a pitcher, a pot, a bread basket, another basket, a brass bucket, and a foot-warmer. Cross-axial design depends upon this improbable proliferation (fig. 21). The diagonal which passes behind the figure is weak, and the foot-warmer will not bear the column of space it is asked to support. But if Vermeer allows the figure too much margin on one side, he allows her too little on the other. We follow a fold of tablecloth, but we shall not encircle her without effort in that distraction of objects (fig. 22).

The Maidservant is a latter-day Martha of Vermeer's earliest extant work, *Christ in the House of Mary and Martha* (fig. 23). Each girl attends a modest household chore with humble downturned eye: Martha steadies a bread basket with her left hand much as the Maidservant steadies a milk pitcher. In both paintings Vermeer means to reconcile *vita activa* with *vita contemplativa*, as if sleepwalking were the ultimate oxymoron of human conduct. He consecrates domestic labor, and each girl seems at ease with her estate.

Vermeer's Martha, in other words, is neither the burdened figure in the painting which is his own "chief source" (a version of the story by Erasmus Quellinus the Younger)[6] nor the figure in *Luke,* "cumbered about with much serving," who complains to Christ that Mary will not help with the housework.[7] "Martha, Martha," He answers, "thou are anxious and troubled about many things"—and, besides, Mary "hath chosen the good part" by sitting at His feet and listening to His word. Vermeer elides Martha's anger but not Mary's attentiveness: she listens with an alert eye.

Martha becomes the Maidservant, but Mary, who is more handsomely dressed, is not destined for domestic servitude. The attention she devotes to the Word her descendents, like the Woman in Blue, will devote to the written word. Vermeer rejects Biblical anecdote and Greek myth, but as he paints against the *Diana,* he paints through the *Christ.* This very early work is the sacred model of a familiar scenario: the introduction of a male visitor into a female domicile. It initiates that "journey into the interior"[8] which will emerge, in later paintings, as his truest subject.

This journeying into consciousness, toward a conscious weighing of choices, is precisely the circumstance of the Lady Weighing Gold, i.e., a Woman Holding a Balance (fig. 24). Like the Young Lady with a Necklace, she stands opposite a mirror. But, like the Maidservant, her eyes seem closed upon

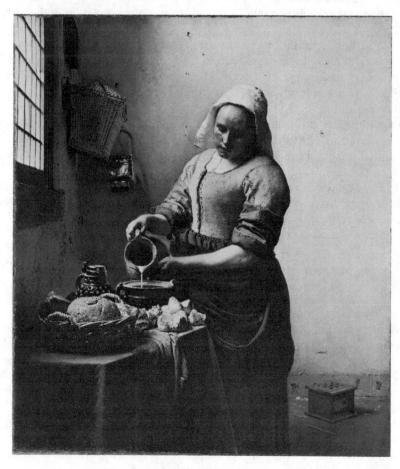

Fig. 20. *Maidservant Pouring Milk* (ca. 1660-62)

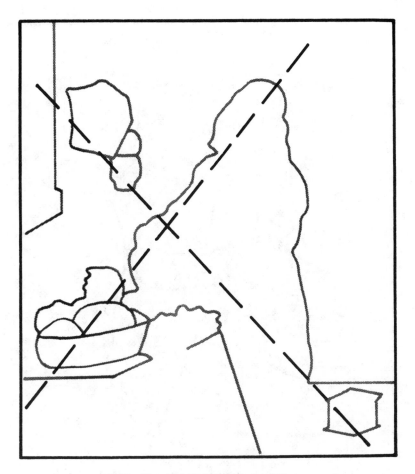

Fig. 21. *Maidservant Pouring Milk*

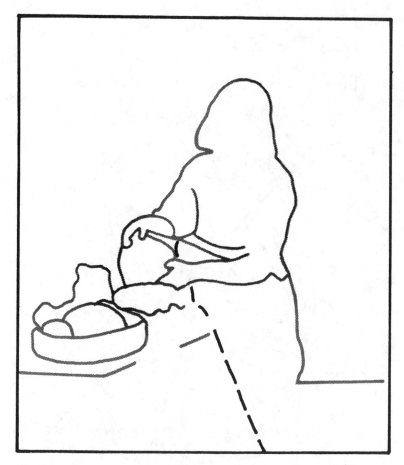

Fig. 22.　*Maidservant Pouring Milk*. As the maidservant stands in the general direction of the light, we too must move (again) in that general direction before attempting to encircle her at the waist.

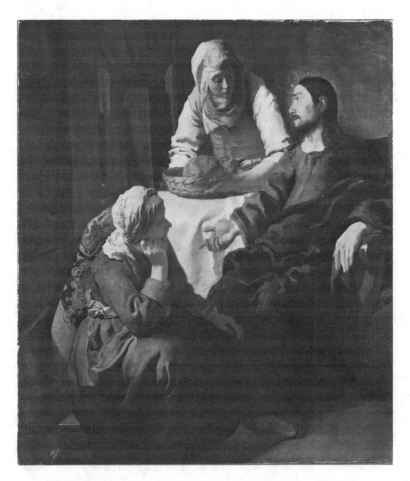

Fig. 23. *Christ in the House of Mary and Martha* (ca. 1654-56)

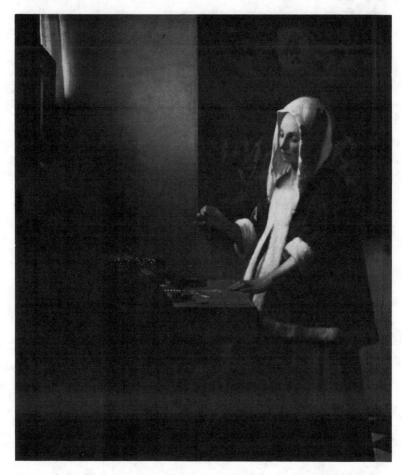

Fig. 24. *Lady Weighing Gold (Woman Holding a Balance)* (ca. 1663-65)

her work. Will she espouse a life of pleasurable ease (as symbolized by the cavalcade of pearls) or will she endorse a life of moral rigor (as symbolized by the Last Judgment)? The scales, which are empty, are ready to be weighted.[9] The painting divides at the crossbar into upper and lower halves of equal weight. Will the lady choose a higher center of gravity or a lower? Will she be kin to the Woman in Blue or to the Young Lady? Like them, she is pregnant and pregnancy is the metaphor of her suspension. Will the scale tip toward vanity or humility? Her fate, as we say, hangs in the balance.

Vermeer locates the Woman Reading, the Woman with a Water-jug, the Woman in Blue, and the Maidservant Pouring Milk in the center of the canvas. He locates the Girl Asleep, the Laughing Girl, the Young Lady with a Necklace, and the Woman Holding a Balance to one side. These acts of location are not accidental. The center is the preeminent zone of the sacred because "a universe comes to birth from its center; it spreads out from a central point that is, as it were, its navel."[10] The physiology of the center is female. The Woman in Blue is an *axis mundi,* a navel from which the world spreads, a source of being. Woman exists before man in Vermeer as a datum of mythological priority. The personae of the oneiric house are necessarily female.

The women of my first group are of undisputed rectitude, moral centeredness. The women of my second are tempted by the world and the flesh. They are not tainted but neither are they reminiscent of Marian archetypes. They do not violate the chamber of being, but they are displaced from its center. In a mythology of morals this displacement is deconsecrative. Vermeer encloses hallowed space, but hallowing is reversible and merely requires the breaching of boundary. In a mythology of morals this breaching is desecrative.

Nevertheless, one cannot breach a boundary which does not exist, and the earliest paintings are mere gestures toward a phenomenology of within and beyond. Christ does not violate the House of Mary and Martha (though He sits inside it), and neither the musician nor cavalier threatens the prostitute (though each is behind her barricade). The *Soldier and Laughing Girl,* on the other hand, threatens violence it chooses not to consummate: the Soldier is at once an irresistible force of nature and an immovable object in nature, as double as the girl who invites and forestalls. He seems destined to penetrate her private recess even as he rises before us like some massive escarpment which partially inhibits but cannot entirely deter the sea, that flow of space and light around his shoulder and past the base of his spine, through the crook of his elbow and down the channel outside his arm. The Soldier prepares us for force, but the civilians who conduct the final assault triumph by craft.

The *Girl Interrupted at Her Music,* the *Couple with a Wineglass,* and the *Girl Drinking with a Gentleman* have been "closely [and justly] linked" as "scenes of fashionable life;" and Gowing's perception is correct as far as it goes: that in them "Vermeer embarks on the elegant anecdotes which his contemporaries were elaborating under the influence of Ter Borch."[11] The

fragment of a painting within the *Girl Asleep* depicts Cupid's mask and leg; the painting within the *Girl Interrupted* depicts the rest of his body. Sexual love, once lurid and secret, is now domesticated and social. Natural desire is channeled into *courtoisie*. Has Vermeer grown frivolous? In fact, these paintings belie all frivolity. Their dramatic content is much more consequential than bourgeois settings imply. We perceive in them the process of transgression. Although Vermeer does not use the same models in all three paintings, the three paintings nevertheless comprise a narrative sequence of the Fall of Man.

In the *Girl Interrrupted* a gentleman—not a soldier—breaches the barricade of a girl who does not defend it (fig. 25). How serious is that breach? Not serious at all according to the girl who stares us down. Her affair is none of our business. We are the intruders. Nevertheless, for the first time in these paintings a woman receives a man in the deeper privacy of her chamber. Crossing a threshold in Vermeer is never a ceremony of innocence, though no one—save us—raises an objection. Two lions'-heads, inspired perhaps by the profile of Mary at Christ's knee, bear silent witness. Music remains the food of love. A glass of wine remains to be drunk.

The *Couple with a Wineglass* concerns a woman at the point of falling (fig. 26). Her tempter has grown grim about the mouth and oleaginous in his encouragement. His unearthly hand floats before her, as he studies her face. We know, no less than she, that to drink that glass of wine will seal her fate. The tempter is symbolized by the stained-glass figure of "la dangereuse dialectique" who holds two coiled snakes, the coils of argument which ensnare a victim.[12] Two chaperones—they may as well be lions'-heads—sleep at the table and watch from the wall. The girl is riven by allegorized impulses—the tempter at hand, the elder in the painting—and she succumbs to what is at hand. She raises her glass against her better judgment and begs not our mercy but our understanding. She accedes to her fate. A partially eaten orange lies inside the plate; a twist of rind coils outside it. We discover the snake and the fruit in this violation of boundary.[13]

In the *Girl Drinking with a Gentleman* the last drop has been drunk (fig. 27). The tempter, shrouded in a cloak of invisibility, watches more with pity than desire. Unlike his predecessor, he is more witness than voyeur. Unlike her predecessor, anchored to the frontal plane, the Girl Drinking is adrift in space. The closure of her arms suggests her animal vulnerability; being shrinks to the enclosure of her face, the fragile and transparent glass. Vermeer interchanges lions'-heads with chaperones, chaperones with lions'-heads, but all our surrogates are silent. There is doom in that empty glass, but now it is too late. We reckon the passage of time in the passion of light: cool in the *Girl Interrupted,* warm in the *Couple,* intense in the *Girl Drinking.*

In the course of these three paintings Vermeer gradually relaxes a narrow angle of vision and a close view of his figures; he retreats to a point of (what

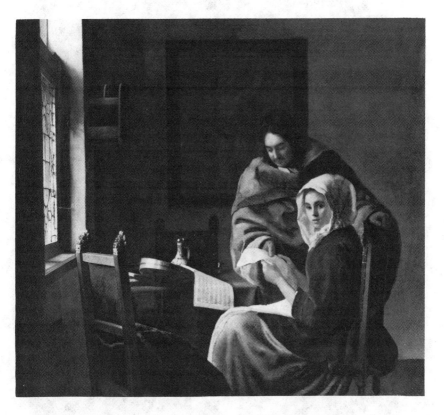

Fig. 25. *Girl Interrupted at Her Music* (ca. 1660-62)

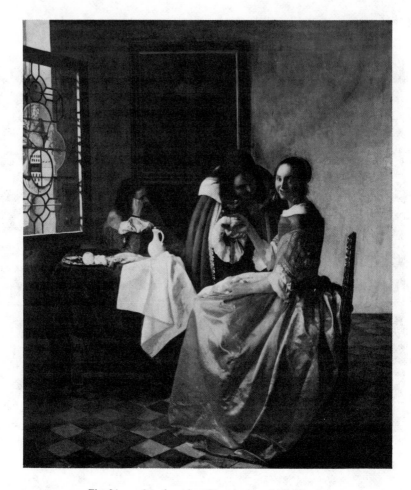

Fig. 26. *Couple with a Wineglass* (ca. 1660-62)

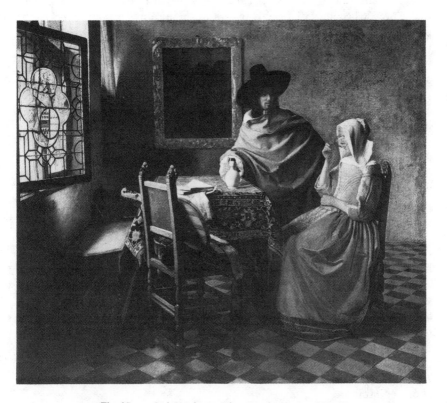

Fig. 27. *Girl Drinking with a Gentleman* (ca. 1660-62)

seems to be) neutral survey. As if the Creator were permitting his creatures the unmistakeable fate they had chosen! In the *Couple* and the *Girl Drinking* the floor-tile is a unit of measurement for the first time, and interior space seems more rational than ever before. These tiles tempt us to measure the oneiric corner, and the permeable barricade of furniture in the latter painting tempts us to penetrate it.

If we neither measure nor penetrate, it is because these spaces are less rational than we first suppose. The further Vermeer retreats from his models, the clearer it becomes that the rear wall of these rooms is not parallel to the picture plane. In the *Girl Drinking* a recession of tiles curves to the horizon of the floor. Slanting wall and curving floor imply an irrational architecture. The intimations of spatial irrationality and moral failure are analogues of one another in this painting. Being drains from the subverted cube.

Rejecting explicit descriptions of nature (after the *Diana*), Vermeer creates landscape and seascape by implication. The *Woman with a Water-jug* implies a fertile garden; the *Girl Drinking,* a less than pleasant place. Slanting wall and curving floor suggest that interior space is becoming unenclosed, that it is losing the impress of human value. In the seventeenth century, Holland was (and still is) a province of dikes, and "nowhere else has the feeling of a human wall opposing the sea been so strongly developed."[14] Vermeer's interiors are geographies of incursion and resistance. There is a perpetual antagonism in them between nature and culture along a shifting boundary of consciousness.[15]

The painting in the *Girl Drinking* is a landscape, for landscapes decorate the walls of compromised women. For those who have lost the Garden, a landscape offers the consolation of illusion; however, the literally truer redaction of nature on a two-dimensional plane is a two-dimensional map which makes no pretense to a third. The larger problem does not concern landscape painting but painting itself: *any* three-dimensional event projected onto a two-dimensional screen fosters an illusion of the world. Vermeer was well aware that he could neither resolve this problem within the limits of linear perspective nor violate those limits. He presents this dilemma to us in the *Painter in His Studio,* a painting—more than any other in the *oeuvre*—which is about painting.

The landscape of the *Diana* is partly borrowed and partly imagined but gives no evidence of having been seen. The townscapes are another matter, for they are very sharply observed. Vermeer painted at least three of them. One is lost and one is the *Little Street,* but the third is one of the great paintings of European history, the *View of the Delft* (fig. 28).

It is not difficult to find examples by fifteenth century Northern masters in which a fanciful Nazareth or Jerusalem extends along a rearground plane: the *Three Marys at the Tomb* by the van Eycks, for example, is all turrets and towers. The panoramic townscape, like the landscape, remains in the distance and does not become an important subject of European painting until the

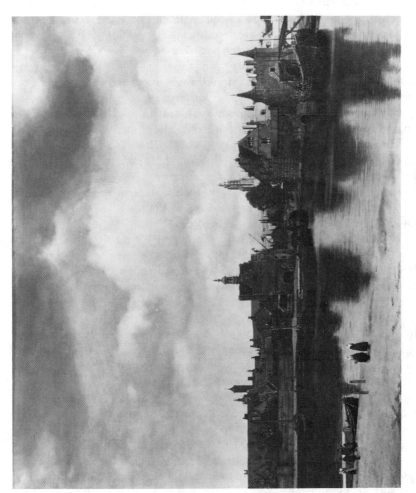

Fig. 28. *View of Delft* (ca. 1660-62)

seventeenth century. Then it is as if painters took telescopes, looked deep into the pictorial space of their predecessors, and magnified those remote cities and countrysides. The *View of Delft* has the unanticipated objectivity magnification bestows, though its extraordinary panoramic character is not owing to the telescope but to another optical device, the *camera obscura*.

Vermeer painted the *View of Delft* from a certain elevation—perhaps a second storey—but what is most consequent about his vantage is that he chose to see so little, not so much. We are permitted the amplitude of air and sky, but the low and distant buildings between State House and New Church forbid us the prospect of infinity. Vermeer organized the space of his painting as a cone, not a funnel. Three planes below (strand, river, town) and three overlapping cloudbanks above recede toward and converge at these buildings, and we cannot see beyond them. Like an unpunctuated interior wall, they intercept our view and remind us that, for an artist so inspired by prohibition, outer space no less than inner must have a stop.

Vermeer is a geographer of a very special kind, for his painting is not just a View but is a Vision: a topographical rendering of a golden city dominated by spires and steeples, inaccessible save by water like Dante's Terrestrial Paradise. As in the *Maidservant*, Vermeer spiritualizes the mundane in "pointillist" incandescence. In the *Three Marys*, according to Panofsky, the rising sun, which "casts a rosy light upon the city of Jerusalem," symbolizes the rebirth of Christ.[16] On our side the river Schie in our painting the strand is dull and flat, whereas, over the other, a morning sun in the crystaline air of Delft suggests a city blessed by light, a New Jerusalem. The intersection of Heaven and Earth lies in the middle distance.[17]

In 1654 Delft was visited by a "thunderclap" at the town arsenal, an explosion of eighty thousand pounds of gunpowder in which two hundred houses were destroyed. The painter Carel Fabritius was killed, and another painter, Egbert van der Poel, made a small specialty of the disaster. Vermeer never alludes to this extraordinary event: he is a painter of consciousness, not history. He paints Delft under high and solemn clouds, *sub specie aeternitatis*. His poetry of meditation is so intense that it returns us to our soul-self.

It is possible that, like certain nineteenth century masters, Vermeer regarded the sensuous landscape as a projection of the divinely feminine: that is one way of regarding the *Diana*. In any case, quite early in his career he reconstituted that projection within the confines of a bourgeois chamber; that is his special triumph. The View of Delft, however, is neither feminine nor a landscape; it is a masculine townscape. Our sense of its sanctification derives not from the immanence of Mary but from that incandescent shower of light, the vicarious presence of the Father God who has withdrawn beyond the waters and into the sky. The holy manifests itself within the chamber or beyond the world.

The *View of Delft* is a painting of supernal loveliness, but Vermeer is more contrary than we usually allow. There is nothing supernal—nor thrilling, nor glorious—about the *Little Street* (fig. 29). As he dies before the *View of Delft,* Proust's novelist Bergotte sees his life on one side of a celestial scale and a "little patch of yellow wall" on the other. His last words are "petit pan de mur jaune," for he senses in that luminous patch an ultimate loveliness, the art toward which he should have aspired, the books he failed to write.[18] The *Little Street* is an excellent painting but not likely to engender a final vision.

Vermeer is as ruthless as the *camera obscura* allows, as self-denying as roofs compressed—as children playing—at right angles. He severs the crown of a building and the branch of a tree (so much for landscape!) and slashes through the building itself in an act of wilful antisentimentalism. He denies thresholds their sacred power to inhibit and enchant. If a closed door tempts us "to open up the ultimate depths of being," opened doors remind us that we shall not find an ultimate loveliness in any human space.[19] Women are about their chores, but the daily task is untransformed. Waste water trickles from an alleyway. Unlike the *View of Delft,* the *Little Street* records profane space: shallow, flat, compressed. Vermeer turned fromt the temple to the labyrinth in order to paint it.

As the *Little Street* is a townscape which resists deep space, the *Music Lesson* is an interior which embraces it. It is, in fact, another seascape by implication, though Vermeer now inverts the spatial flow of the *Girl Drinking* (fig. 30). Floor tiles do not recede now into an uncertain distance but advance toward us with Euclidean exactitude: from an open corner, along an escarpment of tapestry, through an open channel. Being flows from the cube of light. A suitor need not insinuate himself into this lady's chamber. His problem will be getting out, for in the ravishment of amber and violet air, a woman seduces a man, and the man, confined within a series of notched planes, is not the lady's conqueror but her captive (fig. 31). Furthermore, there is

enough of the painting on the wall to discern...a prisoner, kneeling with his hands bound behind his back. But it is sufficient to illuminate the rapt look of the gentleman in front of it. In fact, it is part of a *Roman Charity,* calling to mind an inconceivably abject dependence of man upon woman [i.e., of a woman feeding a man from her breast].[20]

The gentleman is trapped in a world where everything, including himself and his antagonist, is double, or treble, or quadruple. The tile on the floor, the glass in the windows, the beams in the ceiling, the design on the virginals, the folds of the tapestry—no other Vermeer incorporates so much repetition or the paralyzing entrapment it implies. The opaque jug dominates its tray as if it were a fallen foe. How shall the gentleman ever succeed in a contest of love? How shall he ever undo his lady's dominion?

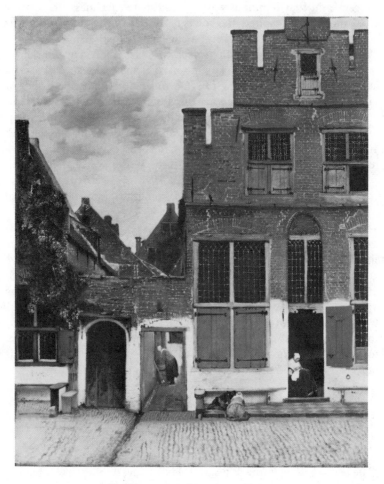

Fig. 29. *Little Street* (ca. 1657-59)

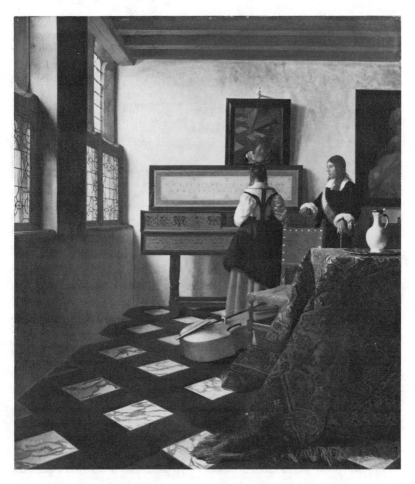

Fig. 30. *Music Lesson* (ca. 1660-62)

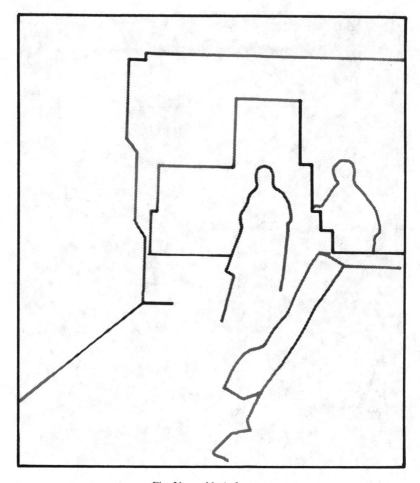

Fig. 31. *Music Lesson*

The inscription on her virginals is "Musica Letitiae Co[me]s Medicina Dolor[is]." Music is the Companion of Joy, the Cure of Sorrow, but the gentleman is without companion or cure. He does not play his instrument, and he does not accompany his lady. Each is disclosed in a moral design so artful we may not at first notice it: all space is available to her, none to him. Vermeer pursues the sexual dialectic of the *Soldier and Laughing Girl* to this extraordinary reversal. The Girl's enclave, once breached, becomes a gentleman's confine. The incommensurable corner becomes a veritable perspective of floor-tiles we can count. Visual space here is metrical and profane, and the long prospect of the *Music Lesson* is a melodrama of visuality. The lady at the virginals has learned to appropriate the world, not suffer it: she has learned to captivate and capture. She dominates an unbounded space—as only men had heretofore—and she does so as a function of consciousness. Her suitor is cribbed and cabined, and there is irony—even poetic justice—in their exchange of roles and places.

The solitary woman with downturned eye is an archetype of introversion. She dreams of love, reads a letter, pours milk, holds a balance. If mastery of outer space is a function of consciousness, and if visuality is its instrument, she rejects this mastery and refuses this instrument. She potentiates an inner realm and does not see (or care to see) beyond the pale of her privacy. The presence of men challenges the virtue of her inwardness, though even in those paintings in which women seem most ready to advance beyond their native confine, they do not do so. The Girl Interrupted at Her Music looks at us, the girl with a wineglass looks to us, but neither looks (nor means to look) beyond us. The lady at the virginals, however, is as clever as Perseus. She watches her victim in the glass and conquers by an act of reflection even as an edge of canvas cuts the head off a kneeling prisoner. The *Music Lesson* is serious combat, not a mere "battle of the sexes." The way of the world is a triumph of the profane. And when we extrapolate the tesselation of milady's chamber, we understand that her space flows directly into ours and that we are secret sharers.

In the *Concert,* which seems a companion piece of the *Music Lesson,* three people easily occupy an unencumbered depth: a courtier plays with one woman as another accompanies them (fig. 32). As nature in the *Diana* (dog, plant, and "bird") is sublimated into tapestry in the *Woman with a Water-jug,* so human nature in the *Procuress* (bawd, prostitute, and client) is sublimated into painting [i.e., Baburen's painting] in the *Concert*. Baburen's *Procuress* gives the lie to romance. Two landscapes give the lie to innocence. Two idle instruments suggest a clientele of suitors, as dalliance hardens in the workaday world. Vermeer anatomizes melancholy in the guise of pleasure, but we must not suppose we have caught the master in the merely didactic. Light falls impartially into this fallen and partial world, and moral certitudes pale in a blazon of yellow sleeve.

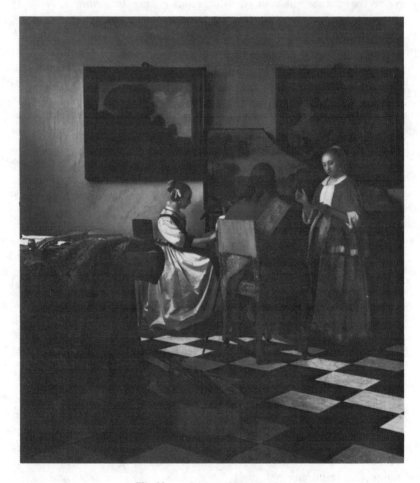

Fig. 32. *Concert* (ca. 1663-65)

The courtier in the *Music Lesson* waits, walking-stick in hand; the courtier in the *Concert* has relinquished his stick for an instrument. The saraband of complicity between men and women—of men seducing women and women frustrating men—completes itself in this painting. In portraits of the solitary model, however, the analogue of this complicity is not (of course) the reception of a man within but the extension of a woman without. The Woman with a Water-jug raises half-opened eyes to a half-opened window, but the Lady with a Lute—in a painting strictly comparable—raises her eyes in dawning curiosity and looks through the window (fig. 33).

Once again Vermeer juxtaposes planes which extend into space at different depth: the lady's sleeve and the table edge, the back of her head and the point of the map bobbin, the tip of her instrument and the bottom of the mapstick (fig. 34). But the optical ambiguity of this painting concerns entrapment, not dismantlement. An ambiguous ligature runs from the bottom of the lady's sleeve to the tip of her lute, compressing the region between the table edge and the mapstick. This ligature locks her into the corner. Her freedom, so to speak, lies through the window. She is tuning an instrument, listening self-consciously, and is perhaps more intent on what she hears than what she sees. Nevertheless, she looks through the window—she extends herself in the direction of the outer world. This is a moment of consequence in the natural history of Vermeer's personae.

The *Woman with a Water-jug* is oriented toward an ambiguity of being; the *Lady with a Lute* (rather less evocatively) recounts the ambiguity of moral status. The lutenist is alone, but the bass-viol implies a visitor. She encloses herself yet issues herself forth. Her lions'-heads are dark as she turns into the light. A map is on the wall, but tiles are visible on the floor.

If letter-reading in Vermeer is a mark of deep subjectivity, letter-writing, like looking through a window, is a way of issuing forth. As the consciousness of his sitter expands, her unselfconsciously embodied chamber contracts. Vermeer respects this law of conservation and reciprocity, as the flattened space of the Lady Writing a Letter testifies, the shallow foreground in which she is wedged (fig. 35).

Sitting at table, pen in hand, she observes us with a frank and intelligent eye. Unlike the Girl Interrupted at Her Music, she is not a novice, and though we have intruded ourselves, she makes no effort to resent us. She has evidently assimilated a knowledge of men and things: although she does not play an instrument, a remembrancer of musical instruments on the wall commemorates an older passion. The life of dalliance is literally behind her. To be at home in the world (as she evidently is) is to be rapt of the sacred enclave; to observe us (as she evidently does) argues a diminishment in oneiric aptitude. But Vermeer neither sentimentalizes her youth nor satirizes her maturity. He acknowledges her poise and good nature. He bestows ribbons upon her and makes the best case.

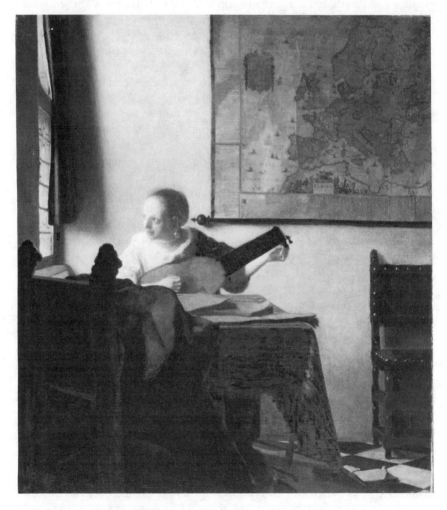

Fig. 33. *Lady with a Lute* (ca. 1663-65)

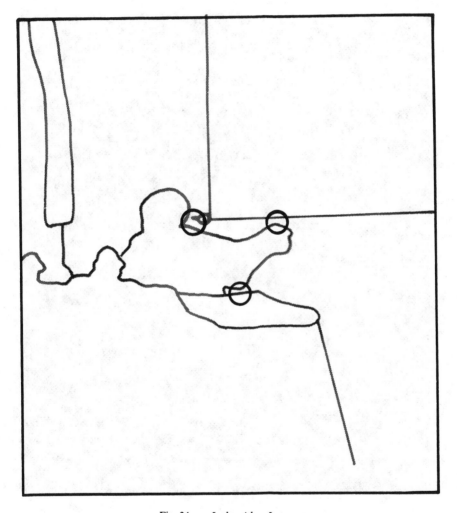

Fig. 34. *Lady with a Lute*

Fig. 35. *Lady Writing a Letter* (ca. 1663-65)

Fig. 36. *Young Girl with a Pearl Ear-Drop* (ca. 1663-65)

Vermeer practices an art of quintessential moments, but even in an *oeuvre* in which nearly every painting carries a definitive burden, the *Young Girl with a Pearl Ear-Drop* is a remarkable concentrate (fig. 36). Like the Lady Writing, this girl also observes us, I doubt if there is depicted anywhere in Western painting a gaze of purer vulnerability. She is as empty of self-possession as the Lady Writing is full. Shock of discovery registers in the dismay of her mouth and the incredulity of her eyes. What plunges her into this darkness which knows the configurations of neither space nor time? What robs her of childhood shelter and the human matrix?

"We have only to seek the farther surface of [her] nose or the precise shape of [her] nostril to know it was never there," writes Lawrence Gowing. "Vermeer seems almost not to care, or not even to know, what it is that he is painting."[21] He paints the world as if he had never learned the schemata by which men represent it, and he attributes to this child his own childlike clarity and registration. It is as if she were seeing us for the first time, as if, in an access of consciousness, she had focussed on the other for the first time—nothing less mythological than that. And that is why Vermeer represents her as a child (though there is nothing childish about her). How else could he even begin to render probable this mythological moment, this otherwise indescribable fiction?

Vermeer, who renounces all flora and fauna, privileges the pearl. It is an archetype of autonomy, a confirmation of seamlessness, a matrix of light in a shapely enclosure. Like the pregnant Woman in Blue, it is the round shape of being, "an intimate immensity."[22] The interiors aspire to its condition. Oneirism finds a natural analogue in its perfection. The pearl and the head of the girl are rhyming shapes, for each is a concretion of purity.

The *Young Girl* mythifies its model. It purges consciousness of its milieu and reduces it to primary colors. It extinguishes the cube of light. The diminishment of oneiric space ends in the apocalypse of all space.

3

Exile and Everyday Life

Like Cézanne, Vermeer is wary of deep and precipitate space, and in the *Painter in His Studio* (fig. 37) he chooses to represent the faraway by a map rather than a landscape. This map is nearly synonymous with the rear plane of his painting and emphasizes the closure of that plane. It is a diagram of the faraway which asserts the near-at-hand. Vermeer's choice, in other words, is at once moral and pictorial, for the map is a nearly two-dimensional screen on a two-dimensional ground, in this sense a truer redaction of nature than a landscape, which (by pretending to an illusory depth) opens a window in the rear wall.

In our interior Vermeer combines two motifs he combines nowhere else: the large and legible map (which appears for the last time) and heavy drapery (which appears for the first). Drapery, in fact, will recur eight more times in the last thirteen paintings, and we must ask what its belated and repeated usage signifies. If it is closed, the space it conceals is conspicuously absent.[1] If it is drawn back, it serves as a *repoussoir*. As the map emphasizes space in front of itself, drapery emphasizes space behind. As the curtain suggests the space of a chapel in the *Woman Reading,* drapery suggests the space of a stage in the *Painter in His Studio.*

The Young Girl (who is violated by consciousness) and the Woman Reading (who is inviolate) have this much in common: each displays the immediate nature of her private self. *But Clio in her laurel wreath wears unselfsconsciousness as if it were not a mask.* She is an actress who impersonates a state of being we do not know she possesses. On cue, she may doff the laurel and don the turbans on her table. Like the poor players in Henry James who impersonate the rich, she is a triumph of artifice, what James in deference to the power of impersonation calls "the real thing." Further: as she mimes Clio[2] (the Muse of History who carries the trumpet of Fame), she also participates in a tableau which includes the Painter and which suggests a Christian model more appropriate than the Annunciation to an allegory of self-consciousness, St. Luke Painting the Virgin. We do not misread the young lady's performance, her "unselfconscious" attitude, though she is a speaking likeness of things past.

Fig. 37. *Painter in His Studio* (ca. 1663-65)

In the *Women Reading* Vermeer constructs an oneiric enclave, which, in subsequent paintings, he celebrates and violates. In the *Young Girl* he banishes it entirely. Now he reconstructs it as the space of theatre. Oneiric space exists again, ironically, as an elaborate impersonation. Like the Painter's costume, it has become a studio prop; like the chandelier, an object of ingenious manufacture; like the "unselfconscious woman," a quotation. The map and the drapery assert the synthetic character of its reconstruction.

In the *Painter in His Studio* Vermeer acknowledges the unadjustable discrepancy between nature and art, a laurel wreath of three dimensions recorded in two. He paints the wreath on Clio's brow in evident depth, but the Painter, working at the moment without chiaroscuro, paints an augury of flatness which announces the conscience of his maker. In this way Vermeer questions the convention of linear perspective by which he makes his painting, and he bestows upon his persona (who can tell the difference between nature and art at least as well as we can) a sense of his own critical self-consciousness.

In the *Painter in His Studio* the world is a stage, the drapery is like a proscenium-cloth, the unfinished canvas is like a play within a play, the painter is like a dramatist, and the model is like an actress. This painting is a theatre-piece "about life seen as already theatricalized" with the characters "aware of their own theatricality."[3] I am quoting Lionel Abel on the "metatheatre" of Shakespeare and Calderón, and I would suggest that the two concepts by which Abel defines a metaplay are also and precisely applicable to our painting. I have already noted one of them (i.e., that the world is a stage); the other is that life is a dream.

The *Painter in His Studio* is an encyclopedia of the major and minor arts (music, literature, sculpture, painting, perhaps architecture, weaving, cartography, and metalwork) and it even records an artistic performance. This plenitude documents an essential psychic want: as if painting the artistic enterprise would somehow renew the configuration of space and time that enterprise had previously represented. One feels now a pressure to literalize—an urgency to confirm—metaphors the artist had previously taken for granted: to recover a subject and its lost instrumentalities. Vermeer's virtuosity, like the Painter's fancy costume, is essentially misplaced unless one can shore his faith in a profusion of objects, but these objects and their profusion merely compensate for a world whose objectivity is in doubt. Life is indeed a dream, and Vermeer's inclination toward allegory suggests an epistemological qualm.

Our painting seems bathed in a fixative of lost time. The map represents the Netherlands as they existed "until 1581, at which date the seven Northern provinces... were cut off from [Catholic] Spain."[4] The Painter's doublet dates from the middle of the sixteenth century, and "the double imperial eagle at the top of the chandelier [is] the emblem of the Habsburgs... who actually reigned when the seventeen provinces were still united."[5] The Painter, elegantly dressed, literally works under the aegis of the Spanish monarchy. The doublet

and eagle are allegories of desire. They allude to an age before Protestant separation and imply a refuge from temporality.

On the other hand, the map is not the innocent instrument it seems: although an outdated map is not unusual in seventeenth century Dutch painting, the long and deep crease in this one happens to separate most of the Protestant North from the Catholic South.[6] The crease runs right through the city of Breda, which changed hands six times between 1566 (when the Dutch first rebelled against the Spanish) and 1648 (when the two parties sealed their division in the Treaty of Münster). Breda was an official residence of William the Silent, the man more responsible than any other for the secession of the North and the Protestantization of Delft. Unlike Velasquez, Vermeer does not commemorate a surrender at Breda, and the ominous crease is nearly the sum of his political engagement.

William the Silent was born in 1533. Raised a Lutheran, a practicing Catholic for more than twenty years, he died a Calvinist. He prosecuted a war of independence on behalf of the Dutch against the fanatical Spanish even as he advocated liberty of Christian conscience. That is why he is not merely the Father of His Country, but is also a hero of European history. He was assassinated in Delft in 1584, a martyr to political and religious freedom, and buried in New Church. Hendrik de Keyser designed a mausoleum in his honor (ca. 1616); and Vermeer, who must have seen it hundreds of times, may have taken private notice of it in the *Painter in His Studio* (fig. 38).

The Royal Mausoleum is an extraordinary construction of columns and cornices, pedestals and pediments, cupola and coat of arms; niches, skulls, obelisks, mottoes, eschutcheons, and epitaphs; statuary of weeping children and allegorical women Valor, Liberty, Religion, and Justice. (The last of these allegories, as in a *Woman Holding a Balance,* is of a woman holding a balance). Two statues of William and one of Fame occupy the central aisle. Wings outspread, resting on the toes of her left foot, Fame blows one trumpet and holds a second in reserve (fig. 39). She is baroque and theatrical and bears no resemblance to Vermeer's discreet Clio. Nevertheless, as Clio holds Fame's trumpet, Fame trumpets William who sits in armor with sash and sword under the emblem of Orange-Nassau (as the Painter sits in fancy dress under the emblem of the Habsburgs). Each holds a cylindrical instrument: William rests his right hand upon a truncheon (symbol of warfare), the Painter rests his upon a mahlstick (symbol of painting). Between Fame (standing) and William (seated) lies a recumbent effigy of the Prince whose white marble face recalls the white mask, oddly angled, on Clio's table (Fig. 40).

The traces of Keyser's statuary in Vermeer's painting are not merely coincidental. One hundred years after the destruction of Catholic images in New Church (1566) Vermeer pays elliptical tribute to the most important Protestant image in that church and to the greatness of the hero who neither sanctioned nor encouraged iconoclasm—even as he grants his persona the

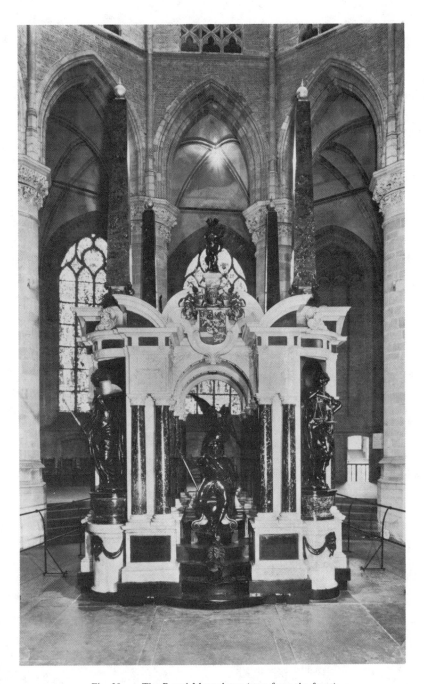

Fig. 38. The Royal Mausoleum (seen from the front)

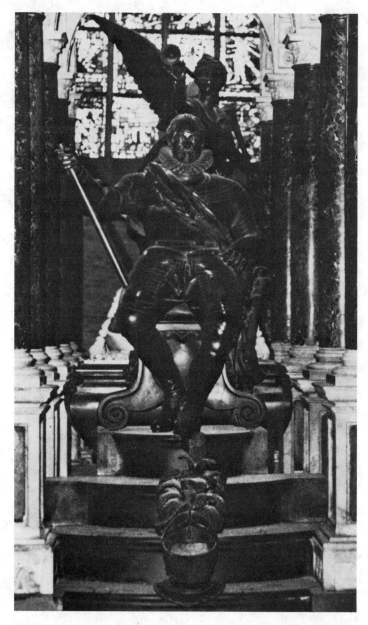

Fig. 39. Fame Blows Her Trumpet. William is seated in the foreground
(seen from the front)

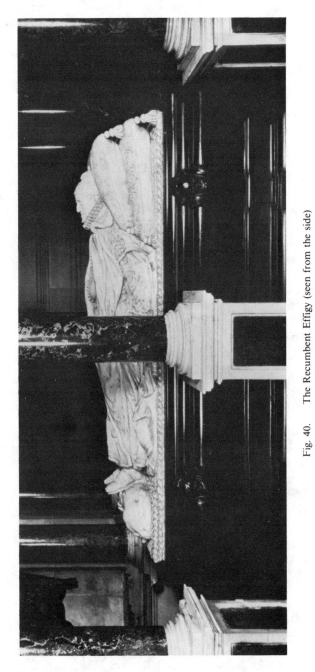

Fig. 40. The Recumbent Effigy (seen from the side)

tribute of an association, neither parodic nor servile, with him. By faint clue and indirection this painting tells the very private estimate of an artist's worth.

Fame is trumpeting William, but Vermeer never urged Clio to trumpet him (and, as the history of his reputation indicates, for a long time she never did). The *Girl Asleep* and the *Young Lady with a Necklace* are *vanitas* images of bodily self-indulgence; the *Painter in His Studio* is an anti-portrait of the artist. Vermeer censors the world and the flesh—and, as the stone crushes the snake in the *Allegory of the New Testament,* he censors the devil too. Prohibition is the whetstone of his genius, but a prohibition against images is not likely to enlist Fame's trumpet. Vermeer celebrates The Painter's Art, the title by which his widow identified our painting. He neither celebrates the self nor advertises the face—if we wish, we too can stand (as Vermeer must sometimes have stood) *behind* the mausoleum and concentrate our attention upon William's back. The *Painter in His Studio* carries this double charge: the temptation of fame and a larger reluctance to seek it.

This painting, in fact, is a composite of multiple loyalties and contradictory attitudes: Catholic unity and Protestant separation, Spanish King and Dutch Stadholder. In the illusory space of the unfinished canvas Vermeer valorizes the notion of plane; on the margins of the map he paints twenty townscapes in depth. And the map itself, after all, *is* a landscape: a European landmass rises above the Painter's head like Mont St. Victoire. There is nothing straightforward about Vermeer's performance. If you want to identify the angled mask, you must angle your own head. The mask is a part which exemplifies the whole, and the whole (like a map which is not but which is a landscape) is an act of punning and play. Like the *Meninas* of Velasquez, the *Painter in His Studio* is a grand gesture of self-reflexivity.

Vermeer represents the crisis of his art with consummate poise, but he cannot sustain his paradox of repletion. On one hand, he continues to reconstruct dimensioned space in mimicry and dissimulation, as in that large hallucinative pastiche, the *Allegory of the New Testament.* On the other, he acknowledges the flattened space which consciousness (Clio's burden) implies, as in those tiny studies in directness, the *Girl with a Red Hat* and the *Girl with a Flute* (figs. 41 and 42).

These girls have been cast into the narrow spaces of disinheritance: as if the drapery behind them had closed upon that sacred interior from which they are now excluded; as if the richness of that drapery were an intimation of the riches they have lost. The Girl with a Red Hat sits on a bench behind the chair on which she rests her arm—in that narrow space—and her hat shields her eyes from the shock of recognition that both of us are in the same exile. She is older than the Girl with the Pearl Ear-Drop who does not so much discover the world as suffer its impingement, for whom its impression is still so fresh that consciousness bears the physiological imprint of light-filled eyes. The Girl with a Red Hat is exiled in a world she never made and she knows it.

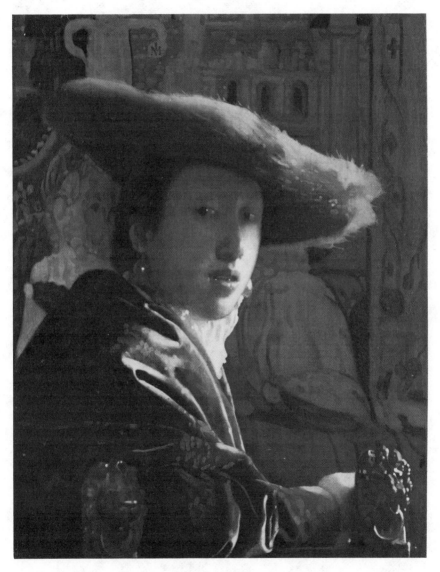

Fig. 41. *Girl with a Red Hat* (ca. 1666-69)

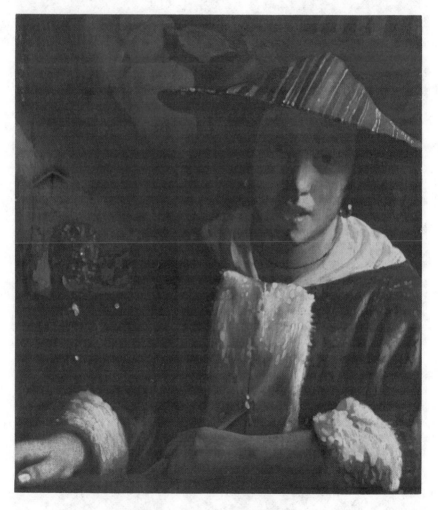

Fig. 42. *Girl with a Flute* (ca. 1666-69)

To a greater extent than ever before Vermeer exploits the alienating effect of the *camera obscura*. Those "discs of confusion" on the lions'-heads are formed by and may only be seen through unresolved lenses; they cannot be formed and may not be seen by the normal naked eye. Vermeer wittingly undercuts the instrument of perception. He does not use the *camera* now (as he had formerly) to purge the eyes of preconception and to clarify unaided vision. Instead, he uses it to create images which cannot otherwise be seen, to confound unaided vision. The blurred lions'-heads—the dissolution of *their* focus and attention—balance his sitters' entrapment in the world that is too much with us. The rings of captivity the lions wear have never been so visible.

The most forlorn person in Vermeer's *oeuvre* is the girl whose flute is the private instrument of her despair. Her dulled eyes do not see, and her face has become a symmetrical and almost detachable mask, rounded equally on either side and flat across the forehead. (But she wears the mask of her own identity, not Clio's.) Vermeer's pursuit of abstraction reaches its limit in the angular planes of her face, in her cheek whose high and low boundaries are defined by diagonals, her nasal cavity which is a parallelogram, and the area below it which is flat and uninflected. She is truncated in a Procrustean space, and the prominent shadow which bisects her nose and jaw divides her face in two. The lighter side asserts itself as a profile in striking anticipation of Cubist two-faced selves, side view and full, in Picasso and Braque (figs. 43 and 44).

The Girl with a Red Hat is a cynosure of consciousness. Her hat is a flaring assertion of self, and the light which models her face endows her with psychological contour. Vermeer deprives the Girl with a Flute of inner and outer plasticity; the fracture through her face signifies a divided (not a doubled) self. There is an elegant manor house in the drapery behind the Girl with a Red Hat, but even that ghostly image disappears in the abstract weave behind the flutist. Vermeer's "retreat from likeness"[7] expresses her withdrawal from men and things into a privacy too deep for tears.

Vermeer's solution to the crisis of art in the *Painter in His Studio* is witty and robust. Literal and allegorical elements cohere as costume drama in theatre space, and the crisis is answerable through its own instrumentalities. The *Allegory of the New Testament,* however, is not so fortunate a painting (fig. 45). We may account for the figure of Faith in a makeshift chapel, even (perhaps) the globes and the apple, but what shall we do with the blood? Dutch interiors of the seventeenth century were notoriously clean, and we have many travellers' tales to this effect. (One, for instance, tells of a maid who carried a visitor across her mistress's floor so that he would not muddy it.)[8] So that even if we can accommodate the allegorical snake, what shall we do with the real blood? Vermeer's interest here is in pollution, not desecration. Faith may have thrown the fatal stone, but who will clean up the bloody mess? A woman violates the space of household husbandry even as Vermeer—at the risk of

Fig. 43. *Girl with a Flute*

Fig. 44. Picasso, *Girl Before a Mirror*

incoherent story-telling—violates a taboo against female uncleanness. Nobody misses the hysteria in this painting.

The *Woman in Blue* is an implicit devotional whose Marian force dwindles into dogma in the *Allegory:* Bible, chalice, cross, crucifix, crown of thorns. Catholic Faith has found haven in the would-be chapel—the peril of the apple and the snake barely averted—but the daydream of faith is unfixed. The newly crushed snake is more than a datum in Ripa's *Iconologia:* he is the chaos of dream frozen in allegory, the nightmare of impingement we call a close-call. What kind of impingement? A love-letter, that sublimation of sexuality, easily penetrates milady's chamber. A gentleman-caller (of modest mien) works his way with sweet talk. A soldier, latently violent and frontal, is checked by a shrewder tactician. A snake, distillate of phallicism, is brutally dispatched. There is a lesson for lovers in the anxiety of Faith's wild turning.

In a battle unto death she reclaims a little of the old holy ground. I have suggested that certain of these interiors are seascapes by implication, and I believe this painting is another: Faith's island platform is like a polder, a tract of land reclaimed from the sea. (Land reclamation is a famously Dutch enterprise.) An opaque globe underfoot signifies this conquest of Earth. A glass globe overhead, symbol of Heaven, reflects the shine of light-filled windows just as in some pastoral far-off place—the tapestry, observes Goldscheider, "not looking Dutch but rather Slav"—a man walks an agreeable animal through a green and pleasant steepled land.[9]

Vermeer separates an inner world of culture (Faith's island) from a surrounding world of nature (the sea-floor). Nature tempts (the apple) and taints (the snake); culture is pure (the globe of light) and redemptive (the cross and crucifix). But the demesne of culture is not only within but also beyond nature and is again suggestive of purity (the tapestried landscape) and redemption (the painted *Crucifixion*). Vermeer's management of spaces is almost cartographic. The sacrament of secret enclosure has become a liturgy of objects in full view. Globes of Earth and Heaven simulate the roundness of being.

The earthly globe is dedicated to the Protestant Stadholder, Prince Maurice (1567-1625), William's son who consummated his father's business by driving the Spanish from the Northern Provinces.[10] The heavenly (I suspect) is dedicated to a Higher Authority. Faith has a foot on one and an eye on the other. Protestantism may rule the Netherlands, but the Catholic Faith extends from Heaven to Earth.

If we could see a painter in his studio in the globe of light—for it evidently reflects the room from which the *Allegory* was painted—we could identify Faith, like Clio, as a model. But if we could identify her as a model, we would have to reduce her status from an embodiment of Faith to an image of that embodiment. Vermeer implies—though he does not confirm—this reduction.

Fig. 45. *Allegory of the New Testament* (ca. 1669-72)

We see through the glass darkly. Faith has more reasons than one for catching her breath.

In the large allegories a painter without a face and a studio without a painter challenge us to supply the missing parts of an artist's identity. In the tiny portraits the prominence of those halations of light compels us to imagine a man behind the *camera*. We feel the painter's presence (in his absence) in these four paintings more powerfully than we feel it anywhere else. The allegories generalize crises of art and faith—they might after all have been painted on commission.[11] The portraits, on the other hand, express crisis in a thoroughly private way. Vermeer abandons the paraphernalia of interiority and strikes directly at the interior life. The portraits are part of a sequence in the definition of sorrow. The Young Girl with a Pearl Ear-Drop suffers a vulnerability to consciouness; the Girl with a Red Hat, an anguish of consciousness; the Girl with a Flute, a disablement in consciousness. Nor is disablement an answer to anguish. The crisis is resolved (or it is not) in the *Head of a Young Woman*, a fourth half-length portrait which complements the first (fig. 46).

The Young Girl and the Young Woman are superficially similar: each is set against an undefined background (not within a space), each wears a headdress and a pearl ear-drop. But these similarities belie a crucial difference. Light animates the face of the Young Girl, and this animation extends to and through her clothes. Unlike the Young Girl who (this instant) discovers us, the Young Woman has prepared a face to meet the faces that she meets. Light lies in pools in the carapace of her cloak.

Yet if the Young Girl is more utterly open than anyone else in Vermeer, more open even than the Woman in Blue, the Young Woman is not as self-regardingly sealed as the Young Lady with a Pearl Necklace. There is a soft edge to her cheek and a softness in her unstartled eyes. Thoré called her "La Gioconda du Nord"—an appropriate epithet for one whose faint and distanced smile is a preservative of personality.

We can trace a dynamic of consciousness in the *oeuvre* through its serenest occasions—those paintings, like the *Woman in Blue*, which are, more nearly than any other, "fixations of happiness."[13] This dynamic leads inexorably to exile. The Girl with a Red Hat and the Girl with a Flute are cast from the oneiric cradle; oneiric space is the irrecoverable *donnée* of their existence. But Vermeer not only excludes the solitary woman from inner space, he introduces the solitary man. The Geographer and the Astronomer, in other words, exist in antiphonal response to the Girl with a Red Hat and the Girl with a Flute (figs. 47 and 48).

Vermeer's first explorer is the cavalier of the *Procuress* whose technic of mapping is by touch. He eventually gives way to the painter with his sublimating brush and visual acculturation, and both yield to these scientists with their globes and devices, their abstract and mathematical means. What do their instruments teach us? That the Earth is round, that the universe is open,

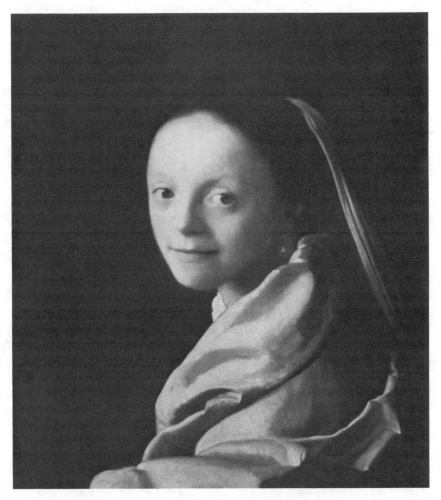

Fig. 46. *Head of a Young Woman* (ca. 1671)[12]

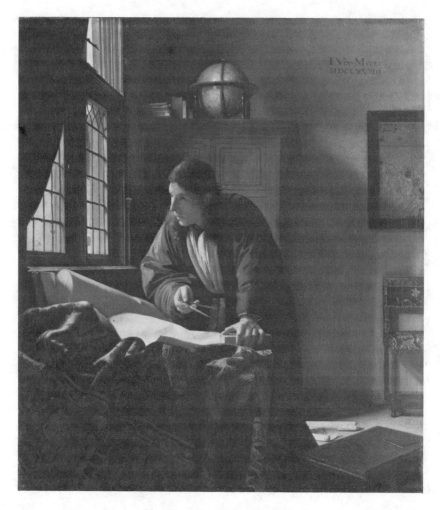

Fig. 47. *Geographer* (ca. 1668)

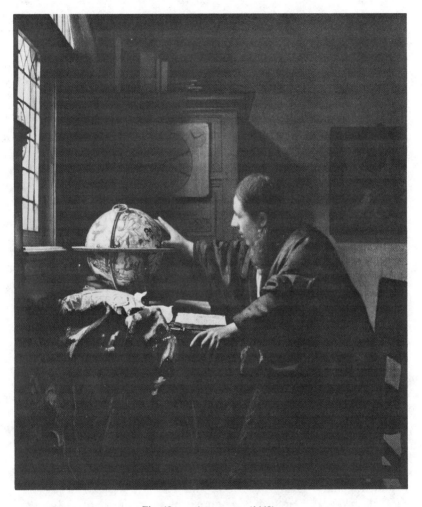

Fig. 48. *Astronomer* (1668)

and that space is homogeneous. Such information is rational and Protestant and precisely the kind of information women in oneiric corners do not endorse. The earth beyond *their* windows is flat—only Faith believes the Earth is round—their inner universe is bounded, they believe space is heterogeneous. Their geography and astronomy is medieval and Catholic.

Vermeer's enclosed women merge into their environments, and this principle of inhabitation is not only not true of the Geographer and Astronomer but the opposite is true. Each is locked in a system of mechanical correspondence; each is parallel to his environment, not one with it (figs. 49 and 50). The alienating way in which Vermeer envisions these scientists is consonant with their own alienating vision. The space of the Astronomer's study is flat; the Geographer's is deep (like the Painter's studio, an impersonation of oneiric enclosure). But flatness or depth is not the point. The task of these paintings—and of those to come—is to outwit an irremediable datum: there is no longer anything oneiric to enclose.

These scientists are serious and dignified men. Vermeer acknowledges the truth they represent—he is an ironist not a satirist—but he regards it as partial. There is a fragment of a painting visible in the *Astronomer* and from a larger and fuller verison of it in a *Lady Writing a Letter with Her Maid* we can tell that its subject is the Finding of Moses, the Old Testament prefiguration of the reception of Christ by the community of the faithful.[14] As we deal in this painting, then, with reference to two kinds of space, we deal analogously with reference to two kinds of truth, a lower and a higher which perfects and completes it. In Christian typology, Christ, the savior who extends mercy, is the perfection and completion of Moses, the law-giver who deals justice. "Inhabited space transcends geometric space,"[15] and scientists of a sheerly abstractive disposition exist, like Jews, in an incomplete Dispensation.

These scientists impinge themselves upon the world; the Young Woman hardens herself against the world's impingement; three other women—exercising the prerogatives of their class—interpose their maids between the world (literally, the window) and themselves. The maid (who brings a letter and who will doubtless take one) is a bulwark of privacy no less than a projection of the explorative spirit, a channel and a barricade. In the *Love Letter* mistress and maid are accomplices, as complementary as the blue and yellow of their skirts (fig. 51). They share the inner space of a confidence as they share the inner space of the painting, and this space, conspicuously special and reserved, is central, deep, and brilliantly lit. In contrast, the antechamber to it is peripheral, shallow, and darkened. A theatrical drapery further accentuates this division. Pattens and a broom delay our entry into this special place, and, as in the *Arnolfini* double portrait, the discarded pattens seem to imply a sacred presence.

Nevertheless, the appearance of specialness and sacredness is belied by motifs whose worldly context we cannot doubt: a woman with a lute, the

Fig. 49. *Geographer*

Fig. 50. *Astronomer.* There is one pun here between the clocks on the chart and the Astronomer's head and globe; another between the Astronomer's angled arms and fingers and the clocks' angled hands.

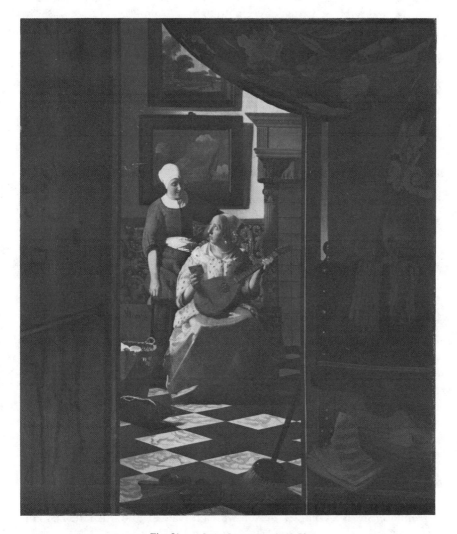

Fig. 51. *Love Letter* (ca. 1669-72)

illusions of seascape and landscape, and the presence of a confidante. Companionship—whatever its virtues—denies the deepening in consciousness solitude inspires. The Woman in Blue communes in her soul's fermentation, but the secret of the Love Letter is disenchanted by discourse, that exchange of knowing looks. Those pattens were not removed from feet in respect of holy ground, and that central panel, which so obviously suggests the silent, limpid depth of a mirror-image (Wilenski, in fact, thought the doorless doorway might have been a mirror) parodies the mirrorical fastness of the virgin's chamber.[16]

Though the foreworld is prosy and crumpled, it too is disingenuously constructed. The two principal objects in it are a chair and a map, and Vermeer deliberately renders them in ways calculated to disguise their attributes. In order to maximize the articulation of a three-dimensional object like a chair, Vermeer ordinarily angles it to the picture plane. In the *Love Letter* he not only deprives the chair of its legs (and conceals much of the rest with books and garments) but, by not angling it to the picture plane, he foreshortens and conceals the seat. On the other hand, Vermeer ordinarily aligns the two-dimensional map parallel to the picture surface for maximum legibility. Here, however, by angling the map and situating it in semi-darkness, he makes it nearly impossible to read and identify.

As the deep and radiant world beyond the curtain is a theatre-space, the world before the curtain—dull and flat—is equally if unexpectedly deceptive. It is more than a matter of map and chair. Vermeer grants apparent depth to an inner world but denies it to an outer: to that extent he retains the propriety of his appearances. But the two worlds of the *Love Letter* are homogenized in a supervening spirit of deception which refutes the appearance of radical dissimilarity. There is no longer a dialectic of ontological difference between them; depth and flatness, insideness and outsideness, are no longer ontological differentia. And yet, and yet Vermeer turns an encroachment of the ordinary to brilliant account: the inner panel of this painting sometimes seems as much a Chinese screen as a mirror-image or a recessed room, the very counterworld of art which resists all worldly displacement.[17]

The maid of the *Lady Writing a Letter* is more than her mistress's accomplice: she is, in fact, the pictorial focus of the painting and its psychological protagonist (fig. 52). She is cornered and, like the corner, is exposed. She stands back from the window through which she looks, and the discontent upon her face reformulates the agon of inner and outer which she personifies. She is a complex person with a private life, not (like the maid of *Love Letter*) a mere appendage. She is caught in the ambiguity of standing back and going forth, and therein lies the drama of the painting.

Her mistress is a foil of apparent serenity. She sits comfortably at table answering a letter crumpled on the floor. The *Finding of Moses* looms behind her on the wall. But as we associate her with a type of the lesser Dispensation, we associate the maid with a crossed (and more interesting) destiny. She (mere

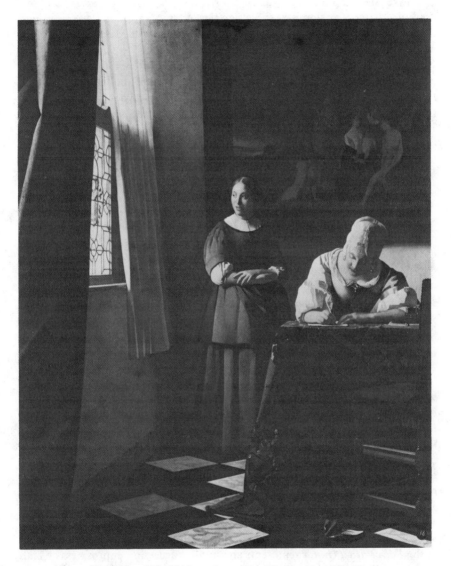

Fig. 52. *Lady Writing a Letter with Her Maid* (ca. 1669-72)

servitor) experiences life more deeply than her bejewelled mistress. And therein lies the irony of the painting.

Like the emptied glass in the *Girl Drinking with a Gentleman,* the crumpled letter is an unmistakeable signifier of temporality. In these paintings oneiric time is parsed into commonplace categories—before and after—as it is not in the *Woman Reading* and the *Woman in Blue.* In those paintings a woman reads a letter throughout an eternal moment, and there is neither evidence of pastness (i.e., of having received that letter) nor futurity (i.e., of finishing it). In the *Lady Writing a Letter,* Vermeer depicts not the continuity of time (as in the perpetual flow of milk from pitcher to pot) but its discontinuity. He depicts it again in the *Lady Receiving a Letter from Her Maid* (fig. 53).

The lady was writing a letter. Her maid interrupts with a second letter. The lady touches her chin in uncertain response. Her lesser uncertainty—about the second letter—screens the larger uncertainty of Vermeer's scenario: should she receive the world within her chamber or issue herself without? She turns to her maid who is not just a sturdy right arm or a creature of independent consciousness but a guide to the perplexed. Her face is nearly full, a compound of light and deep shadow; her mistress's is barely a profile, suffused in a pink glow. These women approach each other across an extraordinary distance— one bearing darkness, the other drenched in light—but they are nevertheless more profoundly intimate than any other couple in the *oeuvre.* Their subject, surely, is erotic entanglement, the denial (as their conversation is a denial) of solitude and silence. In the *Lady Receiving a Letter* larger experience stands in the service of lesser, and Vermeer acknowledges the virtue of society and speech.

Vermeer certainly lived in Mechelen from 1641 until his marriage, at 21, in 1653. Sometime between 1653 and 1660 he moved into his mother-in-law's house in the *Paepenhoek* (the papist's corner) on the Oude Langendijck, where he presumably remained until his death in 1675. Since his mother didn't rent Mechelen until 1669, he may or may not have maintained a studio there throughout most of his career.[19] Its location is irrelevant to the disinheritance of his personae, although the *Lady with a Guitar* (fig. 54), a late painting, does present us with a woman in an entirely unfamiliar setting: a right-hand corner. Nor is it just the corner which disconcerts us. Vermeer had crumpled a letter and crushed a snake, and in these obsessively neat chambers one startles us almost as much as the other, for each is a definition of dirt as misplaced matter. Vermeer had left well-thumbed books about before, but the conspicuous stack in the *Lady with a Guitar* represents an ominous accession of prosiness he had largely and previously confined to the foreworld of the *Love Letter.*

Playing the guitar engenders the perfect pearl of the guitarist's face. The act of art does not restore the oneiric chamber, but it confers a temporary perfection upon the artist, who if she does not transform the prosy world of misplaced matter, transforms herself (even as she may transform her auditor).

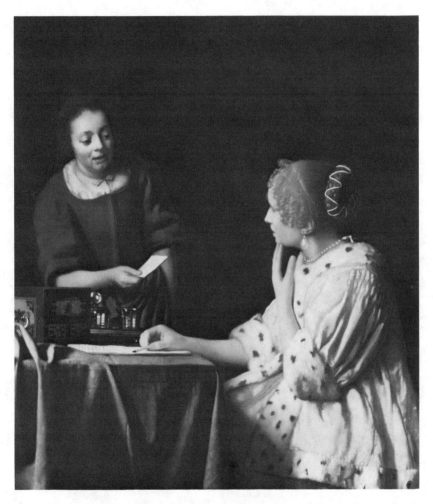

Fig. 53. *Lady Receiving a Letter from Her Maid* (ca. 1670)

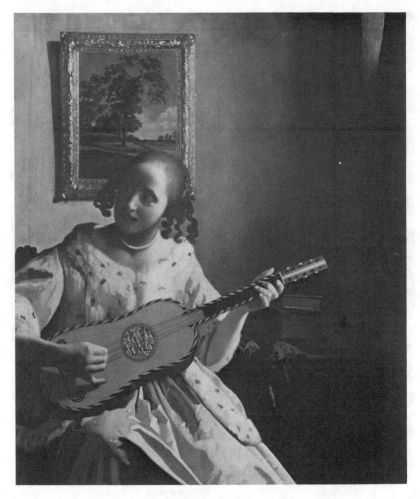

Fig. 54. *Lady with a Guitar* (ca. 1669-72)

She is the constellation of our desire. If we look sharply at and past her head, we may momentarily forget that we are not looking through a window and thereupon experience a mild surreal sensation. If we look sharply, we may see the guitarist liberated from shabby confinement and transported into the lovely landscape. The off-rhyme between her head and the crown of trees encourages this double perspective, but, as in the *Woman with a Water-jug,* we may only achieve the magic enclave through the sesame of our perception. The guitarist occupies a rather forbidding interior, while an apparition of loveliness lies just beyond, the forbidden enchantment of pastoral.

She plays an ornate instrument and exits through an ornate picture frame, the very visible refuge of art. (We can only speculate, of course, about how Vermeer himself framed the *Lady with a Guitar.*) In any case, the guitarist conquers her gloomy cell and journeys into artifice, her song an artifice, her face the artifice of a perfect arc. The transformation of self in serious play is one restorative childhood neither needs nor seeks.

There are neither revellers nor stone-breakers in Vermeer—neither hard play nor hard labor—but making lace surely exacts a more fatiguing expenditure of attention (i.e., requires a more precise coordination of hand and eye) than pouring milk (fig. 55). After the Fall woman bcomes a spinner of thread: "when Adam delved and Eve span." But if the first condition of a fallen world is work, work can also rejuvenate a fallen world. The symbiosis of self and space ruptures in consciousness even as "consciousness rejuvenates everything, giving a quality of beginning to the most everyday actions."[20] The Lacemaker, who cannot resew the severed cord, makes a seamless web. Her thread "liquifies" in the unresolved lenses of the *camera obscura:* red and bloody, she fashions it into lace, symbol of an original wholeness. A child's vision unresolves the canons of Dutch Realism.

The Lacemaker sits at her table before a wall but gives no sign of confinement. She is freed in work as the Guitarist is freed in play. Making lace is not incidental to the profundity of her attention, as pouring milk is incidental to the Maidservant's. Both women are awake yet seem asleep, but only the Lacemaker is transfixed by labor. She works with an immense concentration, and the seriousness of her attack suggests the larger implication of her task. Like Mary at her spindle, she practices a sacramentalism of everyday life.

Nevertheless, she pays the price of her intensity, for her animal and sexual self lies fragmented at the outskirts of her concentration: her "bloody" thread, the braid of hair which snakes around her head, the insectlike implements attached to her sewing box, the holes in the recess of her sewing table, the knobs of cloth and wood. Her face is so impersonally carved by light that it is like a deathmask, and perhaps it reminds us more of the mask in the Painter's studio than of any human face. Vermeer counts the cost of mental and spiritual effort, as if making lace were a parable of making pictures.

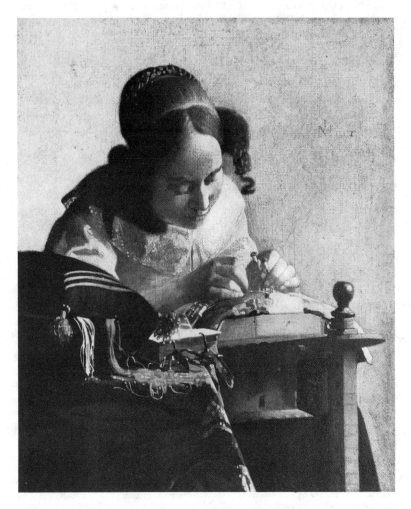

Fig. 55. *Lacemaker* (ca. 1666-69)

The Lacemaker works by light and the light of a higher consciousness; therein lies her virtue and her achievement. The Lady Standing at the Virginals rejects both kinds of illumination (fig. 56). Like unbelievers who turn their backs in brazen pride and denial—I am thinking of that page in the Paremount Mss, the *Holy Ghost and the Unbelievers*—the Lady Standing has turned her back and swollen sleeve.[21] Nor does she want or need a real window or a magic one; realms of pastoral transcendence do not entice her.

Vermeer had painted Cupid before, and Cupid had been a useful metaphor. Now, in his enormity and prominence, he seems part of the substance of the room. The lady need not exit into his landscape of love: tiny cupids decorate the baseboard tiles. In an *oeuvre* in which children are conspicuously absent, Cupid seems to issue from the lady's head, a final and ironic parthenogenesis. Love has become for her an act of pure imagination, love without a lover.

When Vermeer depicts a woman at the guitar or virginals, he commonly depicts her male partner and/or the compatible instrument he will be expected to play. These scenes are staples of amorous insinuation. Vermeer varies his course in the *Lady with a Guitar* and the *Lady Seated at the Virginals*—no gentleman, no second instrument—and certainly the former painting is about the seduction of artistic performance. Even if the guitarist is playing and singing to someone else, it is she too who is being transported.

Nor is there gentleman or second instrument in the *Lady Standing at the Virginals*. But as there is no evidence of a lover and as the lady stands in perfunctory attendance, what shall we conclude? In the *Amorum Emblemata* of Otto van Veen (1608), we find for the first time the figure of Cupid, bow in his right hand, displaying a card or plaque in his left which bears the number one.[22] The significance of this emblem is that a person should love only one, and although there is no number visible on the card in our painting, the implication of the motif is reasonably clear. For if the lady loves only one, it is surely herself.

The *Lady Seated at the Virginals* is a companion piece of the *Lady Standing*: one woman has turned against the light, the other toward the darkness of a shuttered window (fig. 57). The prospect before each of them is an illusion which fools no one, a landscape painting not a magic landscape. The ambiance of the *Lady Seated at the Virginals* is ominously disproportionate: for when the world without is denied, the world within is subject to an unnatural crowding, a densification in self-consciousness. When the dialectic of spaces is suspended, the extravagances of the world within prosper and multiply.

"The bourgeois era of European civilization was marked by the internal deepening of human consciousness," and John Lukacs goes on to observe the analogy between consciousness and furniture. "As the self-consciousness of medieval people was spare, the interiors of their houses was bare, including the

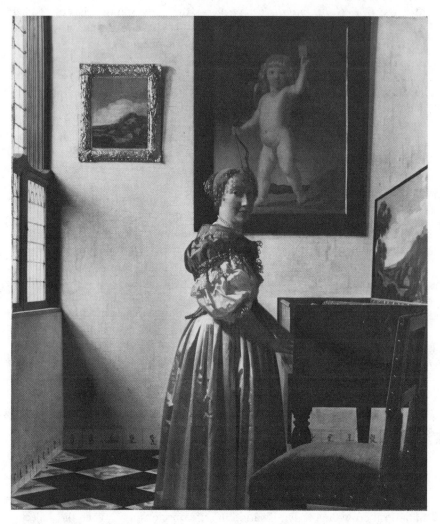

Fig. 56. *Lady Standing at the Virginals* (ca. 1669-72)

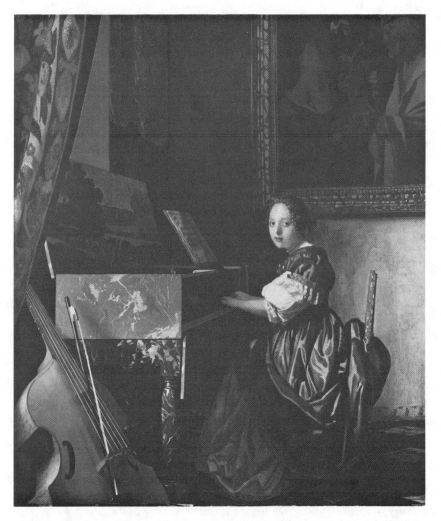

Fig. 57. *Lady Seated at the Virginals* (ca. 1669-72)

halls of nobles and of kings. The interior furniture of houses appeared together with the interior furniture of minds."[23] It is not mere accident that Vermeer's earliest interiors—*Mary and Martha* and the *Procuress*—are nearly bare and that those of his first maturity—from the *Girl Asleep* to the *Lady Writing a Letter* (ca. 1663-65)—are never overly appointed, whereas Clio's studio and Faith's chapel, the studies of the Astronomer and Geographer, objectify a spirit of accumulation. The *Love Letter* is cluttered,and the space of the Lady Seated is more densely crowded than any other space in the *oeuvre*.

And it is not just crowded. Modified solely from within, the furniture of the mind perilously adapts a strictly local color, and we may witness the beginning of this process in our painting. Almost everything in it is a variant or combination of dark blue and light brown, colors which are themselves unmodified in two symbolic instances: in the window-curtain, whose function is to keep the outside out, and the bass-viol, the instrument which will invite the outsider in. Almost everything else, to one degree or another, has yielded its particularity: the drapery, the virginals, the lady's skirts, her pictures. I do not know whether Baburen's *Procuress* is there to celebrate past triumphs or future ones, and I do not know that it matters. An hermetic world is homogenizing itself in the light of its own illusions.

The Girl with a Flute struggles in psychic fracture, but there is no clue to fracture in the shy and uncanny look of the Lady Seated. The clue is somewhere else. The gentleman-caller of the *Music Lesson* is confined within an endless round of desire, the precise intricacies which ornament his lady's instrument. The lady in our painting is exiled within an oppression of objects,a white sleeve in a contracting space. The marbling of *her* instrument is chaotic and disintegrative. Certainly the implications of the *Lady with a Guitar* and the *Lacemaker* are as tonic as anything a bourgeois society might propose: the restoratives of play and work. Certainly the implications of the *Lady Standing at the Virginals* and its companion piece are as fearful as anything to which decent folk in that society might succumb: narcissism and madness.

Through screens of secondary elaboration—the prodigious exactitude of texture and color—we discern a phenomenology of fairyland. In the unlikeliest place—the bourgeois interior—we discern a realm of wonder (or we discern its absence). We realize that silence, solitude, and centeredness are attributes of origin which precede speech, companionship, and that dislocation of being we call the Fall of Man. The oneiric enclosure is an enchanted place whose disenchantment by discourse begins with the *Soldier and Laughing Girl* and ends with the *Music Lesson*. The *Painter in His Studio* arms consciousness against itself, and Vermeer becomes an ironist in self-defense. He revalues artistic performance (which he finally celebrates in the *Lady with a Guitar*) and comes to resist what he had previously cherished, an ethic of pure contemplation. The *Geographer* and *Astronomer* simulate the enchantment of enclosure, but the *Lady with a Guitar* reminds us that a work of art provides its own enclosure of enchantment.

4

In Conclusion

In a *Woman Reading at a Window* Vermeer erects a barricade of furniture between us and the woman and interposes the mullions of a window between us and her reflection. The furniture and mullions suggest narratives of displacement in a space which is itself displaced. My point of course is not that Vermeer mastered the *camera obscura* but that he constructed a space as lucid, silent, and remote as a mirror-image. Huizinga defines the otherness of these interiors as "an atmosphere of memories of childhood, a dreamy calm, an utter stillness and elegiac clarity, which is too fine to be called melancholy."[1]: an impersonal remembrance (Huizinga means) not a private one, and this painting gives the lie to Proust's contention that all paradises are sentimental.

The *Painter in His Studio* recalls Catholic coherence before Protestant division. It is a daydream of wholeness, of that serene and mythological time. On the other hand, the *Allegory of the New Testament* is a nightmare of anxiety—all coherence gone. The Sea of Faith is no longer at the full, and Faith is thrust into an embattled and historical circumstance: as if the stringencies of the Counter-Reformation had not begun a moment too soon. Vermeer substitutes turbulence of nightmare for calmness of dream, suddenness for stillness, embattled feverishness for elegiac clarity. History is the nightmare in which Faith awakens. Her *Allegory* lapses into a naming of liturgical parts in which a still and whole life is broken. Her refuge is an odd polder of consciousness.

Early in his career Vermeer was able to associate the sentiments of unselfconsciousness with a sacred iconology: the Woman Reading and the Woman with a Water-jug are, in this sense, Annunciate; the Woman in Blue is a Madonna del Parto; the Maidservant Pouring Milk a Virgo Lactans. But as he records the conduct of consciousness, the chamber of being vanishes, and, then, in the *Young Girl,* the chamber itself. The *Painter in His Studio* is the centerpiece of the *œuvre*. It looks backward—as in that ironic invocation of St. Luke Painting the Virgin—and forward to the triumph of the artist in the act of making art. Paintings within paintings do not merely allude to the profane character of the rooms they decorate; they allude to the profane character of painting itself. It was not possible for Vermeer to transpose a three-

dimensional event, however sacred, to a two-dimensional plane without practicing a pious deception. (Hence his affinity for maps.) But the *Painter in His Studio* renounces piety. It embraces the necessary lie that making art entails and calmly deposes its ironic faith. The *Woman with a Water-jug* practices deception, but this painting embraces it.

De Tolnay once remarked that "the light of the sun—warm and peaceful—which creeps into [the Painter's studio] is not merely the daily light; it is the light of childhood, the magic of the past."[2] In a painting at once recapitulatory and prophetic, a salute to oneirism and a farewell, Vermeer's "light of childhood" is nothing if not ironic. In any case, the *camera obscura* will fragment the warmth in which Clio bathes; the *camera* obscures the light of childhood, and the Girl with a Red Hat and the Girl with a Flute will leave the magic of the past behind them. The fresh and supple light of the *Woman in Blue* is dry and hard in the *Love Letter,* and the incandescent costume of the Lady with a Guitar has little to do with the warmth and peacefulness of an external source. Such incandescence is largely self-generated, the passionate correlate of playing and song, not of sunny windows. The pictorial adequacy of the doubled self, full-face and profile, in the *Woman Reading* depends upon the realism of reflections, and Vermeer triumphs within the limitations of his syntax. But the pictorial adequacy of the divided self, full-face and profile, in the *Girl with a Flute* depends upon nearly abridging the realism of shadows and surfaces. Vermeer triumphs now by challenging the limitation of his syntax, and nowhere in the *œuvre* is the cross between optics and psychology more sophisticated than in this painting in which a derealization in the texture of things parallels a dissociation of mind.

Vermeer is a psychologist of consciousness whose strategies for partitioning the private self from the social grow increasingly complex. In the *Girl Asleep* the sleeper's face masks a demonism her pitcher expresses: an unsubtle projection of a unsubtle psychology. In the *Music Lesson* the woman's girlish back masks a slyness her (slightly) blurred image in the glass discloses and conceals. In the *Painter in His Studio* Clio's serene attitude masks an ironic consciousness for which there is no physiognomical evidence. Vermeer knows that we become conscious of our apartness from the world in which we live when we internalize the look of the other. Clio simulates a posture of avoidance, but the Woman Reading really does exist (we are led to believe) in a Sartrean *en-soi,* timeless being-in-itself, one with her letter and its contents.

When we become aware of our apartness, we realize that the other not only impinges upon us but that we are isolated as an object in his regard. The Girl with a Wineglass looks pleadingly toward us; the Girl Drinking with a Gentleman drinks as bidden. Each has become an object in the eye of her suitor and discovers her existence in his desire. Each has been rent from an enclosure

of unselfconsciousness and discovers her apartness in the unconfining space of a once-familiar world. Each falls from a timeless continuum into time.

How unnerving, then, that the Girl Interrupted at Her Music should look at us! For in that look we rediscover our existence: at the point where her fall begins, ours does too. We are divided between the *en-soi* and the temporality of the *pour-soi* (being-for-itself); and, like the girls in their sad vulnerability, we are not easily reconciled to this division. A table has been turned upon us, and we suffer the voyeur's embarrassment the suitors escape. The *Girl with a Pearl Ear-Drop* is the quintessential instance toward which these paintings tend: it is an archetype of intersubjectivity. We know and the Girl knows that she is being looked at for the first time. She cannot escape our look, nor can we escape the knowledge of it. Half the sadness of this painting is the violence we visit upon her; half, the violence we visit upon ourselves. How can we ever repair these lesions in consciousness? We cannot of course, but the *Painter in His Studio* does more than wryly institutionalize them. Clio assumes a serene attitude at the Painter's command; the very epitome of time, she seems outside it. Her "recovery" of the *en-soi*—like any actor's—is an ironic convincement that one function of a work of art is to give us our childhood again.

The chamber of being, then, proves an epiphenomenon of narrative, and the *View of Delft*, which makes the least gesture toward narrativity, proclaims that vision itself for Verneer is "the ideal expression of being."[3] We read this panorama from left to right and are reminded of what Ortega called the "guiding law" of European painting: "First things are painted; then sensations; finally ideas."[4] The red roofs, reminiscent of musical notation,[5] are of a hard Eyckian clarity; but when we reach the "little patch of yellow wall" which bemused Proust, Vermeer's manner is so nearly impressionist that the dying Bergotte may well suppose a dormer roof a wall. Vermeer paints the light which pulverizes objects, and the future syntax of European painting lies at the far edge of the *View of Delft*—beyond which the artist himself could not go—in passages of brown and orange, and green, at the edge of consciousness as a collectivity of sensations.

Vermeer unites an impartiality of vision to a symmetry of steeples and towers. Doubtless he was trying to make objects as perfect as the lucent pearl, solid yet animate. But paintings, after all, are not pearls; and his intention is sometimes overborne by the impositions of intellect. *Diana* and the *Maidservant Pouring Milk* suffer these impositions. The *Music Lesson* escapes them. Its orderliness is indisputable: plenitude of repetition, lucidity of interval, shapeliness of virginals and mirror (an abstract set-piece), and that *tour de force* of imprisonment within an ziggurat of planes. The figures (for all their humanity) are impersonal struts, and the pitcher (for all its objecthood) is an icon of imposition. The lady will control the gentleman, and the pitcher will control the tray, but who will control the mirror? It sees what it must. There are

objects in it which are truncated and incomplete—pehaps we can identify the leg of an easel—which are not visible in the room and which Vermeer chooses neither to delete nor explain. And who will control the floor? It advances toward us, its nearest tiles already alarmingly large. We can imagine the next row in the uncorrected vision of a *camera obscura:* huge and grotesque. The dynamic of vision unsettles the presumption of stability. The equilibrium of this counterworld is precarious indeed.

It is equally precarious in the *Woman with a Water-jug.* What we see (an adjacency of objects) disputes what we know (that these objects are in different planes). In the real world we can resolve this kind of dispute (as a playful child will) by closing one eye, but that kind—or any kind—of resolution is unavailable here. The *Woman with a Water-jug* is a painting of intellectual exactitude which expresses a fundamental anxiety in binocular vision. Vermeer sacrifices neither exactitude nor anxiety: he is an intellectual painter who gives full value to visual data.[6]

The *Girl Asleep* grants us the sentimental certitude of a room with a view; the *Love Letter* deprives us of that certitude. Like the *Woman with a Water-jug,* it denies any simple discrimination of the world into receding planes, but its criticism is more thoroughgoing. It is a solid piece of architecture which depends upon the Golden Section[7] but which finally unsettles our notion of the real. No doubt it is a masterpiece of deception. The farther room in this painting resembles an image in a mirror: deep and distinct, seductive, and wholly other. It invites us into a forbidden space. But as the panel itself (not what it represents) resembles a mirror, it also resembles a screen, near and flat, which forbids entry. These contradictory cues put all in doubt. The chamber of being has become a theatre of illusion, and our vigilant eye, which finds no haven, is disinherited.

His vigilant eye sometimes courts anatomical grossness, and I am not alluding to the figure of Faith. Vermeer, who censors feet, plays havoc with arms and hands. He provides the Painter in His Studio a bulbous fist,[8] the Lady Seated at the Virginals a pudgy wrist, the Maidservant Pouring Milk a meaty forearm, the Lady with a Lute an upper arm twice ordinary size (later "normalized" by repainting; since restored), and the Young Woman nothing more than a wedge of flesh. He reserves his grandest stroke for his most elegant creation, the Lady Standing at the Virginals whose right wrist (like Cupid's in the painting) is also pudgy but whose left simply transcends anatomical criteria and is a passage so pure that only Vermeer could have painted it. That vigilant eye, which (like a mirror) sees what it must, seizes an opaque shape we do not recognize with a purity of impression utterly foreign to the claims of Dutch Realism which has seen arms and wrists in the real world and knows what they look like.

Vermeer outrealizes the realists in the verisimilitude of light, texture, and the spatial envelope, but he derealizes them too. The coherence of sunlight in the

Woman Reading disintegrates into innumerable "discs of confusion" in the *Girl with a Red Hat*. The texture of things on one edge of the *View of Delft* reverts to sheer paint on the other. The nap and detail of a carpet in the *Procuress* or the *Girl Asleep* becomes an indecipherable melange of color in the *Girl with a Flute*. The unassailable cube of light is slyly assailed in the *Lady with a Guitar* (where a painting seems a window) and in the *Love Letter* (where a doorway seems a mirror). The *Painter in His Studio* is an exemplary demonstration of my thesis: it acknowledges that Realism itself is an imperfect instrument for rendering the truth of things, that such rendition will escape the procedures of Realism as the laurel on the easel escapes the laurel on the head of Clio.

Vermeer strains the conventional syntax of his time, and, often, suggests a later time. His vision is not photographic, though the magnification of foreground figures is a commonplace of photography. He is not an Impressionist, though he commonly rejects continuous modeling for an impressionist coding of images of light. He is not a Cubist, though the fault lines in the face of the Girl with a Flute remind us of cubist portraiture. He is not a Surrealist, though the seeming insolidity of that solid wall in the *Lady with a Guitar* reminds us of actual insolidities in Magritte. He is not an Abstractionist, though in the rigor of his constructions he has reminded more critics of Mondrian than of anyone else.

And yet Vermeer, who suggests many aspects of modern painting, has been largely unconfronted by modern painters. Picasso once said:

> I'd give the whole of Italian painting for Vermeer of Delft. There's a painter who simply said what he had to say without bothering about anything else. None of those mementoes of antiquity for him [as for the Italians].[9]

But on "spoiling" one of the plates in the *Vollard Suite,* Picasso did not doodle a Vermeer. "I began to scrawl," he said. "What came out was Rembrandt. I began to like it, and I kept on. I even did another one, with his turban, his furs, and his eye—his elephant eye."[10] Picasso did four such *hommages* in 1934, and in his predecessor he found a congruent temperament. In the fourth and most deliberate an admiring Rembrandt (another master of chaste and erotic interplay) takes his nude and very beautiful model by the hand. A spontaneous scrawl ends as an elective affinity.

Miró painted three transformations of the Dutch Interior in 1928, though he too skirted Vermeer. He drew upon Jan Steen and happily transcended the *Cat's Dancing Lesson,* but he didn't confront the greater interiorist. Did he find Vermeer impervious to playful annotation? Or did he think Vermeer deserved a larger reverence than witty transformation allows?

Vermeer's champion among modern painters has been Salvador Dali whose enthusiasm for the master he once claimed to revere before any other is

downright embarrassing.[11] The *Lacemaker* fascinated Dali from boyhood, and in 1929 she made a fleeting appearance in the Buñuel-Dali film, *Un Chien Andalou*. In 1955 she reappeared, now hideously rhinoceroid, in the *Paranoic-Critical Study of Vermeer's Lacemaker*, a title which does not betray its painting. Dali has also disfigured the *Painter in His Studio* in the *Ghost of Vermeer of Delft, Which Can Be Used As a Table* (1934). And so on.

It has required a sensibility more hermetic and reverential than Picasso's, or Miró's, or Dali's to translate the master of Delft into modern terms, but it is also true that Vermeer has been less fortunate in his heirs than in his collateral relations. Joseph Cornell once wrote that Vermeer was "gyroscopic" in his life,[12] and it is not beside the point that Cornell was a maker of boxes first, then of collages and films, and a painter not at all. Those boxes with their facades of glass suggest Vermeerian secrecies and solitudes as no paintings of our century do. For example, Cornell interpreted the poignance of the Young Girl with a Pearl Ear-Drop by locating her in the shabby glamor of the Grand Hotel Bon Port (ca. 1950).

Like the literature about him, Rembrandt's *œuvre* is enormous and comprises painting, etching, and drawing. And if the art weren't sufficient food for analysis, there is the life (which is heroically appetitive), the romantic life (which is heart-rending), the fame, the extravagance, and the bankruptcy. Vermeer's *œuvre* is slender, and he is not the subject of colorful or moving anecdote. Nevertheless, he must have had a certain reputation: he was twice elected headman of the local guild of St. Luke and once called to the Hague to authenticate some paintings. In 1663 a French collector, Balthasar de Monconys, visited Delft, but Vermeer had nothing to show him or, perhaps, chose to show him nothing. The one Vermeer Monconys did see—at the baker's—was much too expensive, in his opinion, for a single figure. In any case, it was not the painter who went bankrupt but his widow.

After her husband's death, Catherina traded two of his paintings against an unpaid bread bill but with this stipulation: that she be permitted to buy them back. She tried a dubiously legal gambit in order to retain possession of the *Painter in His Studio*—she gave it to her mother in partial payment of debt—but was thwarted by other creditors and the representative of the Town Council, Anthony van Leeuwenhoek, who had been appointed trustee of the bankrupt estate. Vermeer and Leeuwenhoek, fellow citizens of Delft, were born in the same year and baptized in the same church; each, in his way, was dedicated to the use of optical equipment. The scientist resolved the lenses of his microscope to see what the naked eye couldn't see—animalcules and bacteria. The artist unresolved the lenses of his *camera obscura* for the same reason—to see those "discs of confusion."

Vermeer painted very carefully—he seems to have been more careful in making paintings than in fathering children—and there seems an inverse ratio between the penitential sum of the one (about forty in twenty years—we cannot

imagine many more) and the celebrational sum of the other (perhaps twelve in twenty-two). He worked as close to his canvas as the Lacemaker to her thread and with equal concentration. He spared neither an expense in spirit nor matter: he used the semiprecious *lapis lazuli* for his blues in every instance save one—a rare gesture among seventeenth century Dutch painters.[13] Doubtless he was trying to make objects as precious as the pearl, insignia of wholeness and the roundness of being.

Vermeer died at forty-three, but there is no man in these paintings to mourn. His personality (as Joyce would say) refined and impersonalized itself out of existence. His paintings seem to exist apart from their maker, apart even from one another, for we do not find among them (as in Rembrandt's self-portraiture) serial sequences which invite lateral comparison. Each painting is complete, and despite the premature death of the artist, it is impossible to say the *œuvre* is incomplete.

Roland Barthes argued that the world in seventeenth century Dutch painting is an object for use,[14] but Vermeer's *œuvre* argues that it is an object for wonder. The final enchantment of these paintings lies in their approximation to Blake's dream which seeks to renew the world rather than to domesticate it: "If the doors of perception were cleansed every thing would appear to man as it is, infinite."[15] Vermeer caught and held the world in the purity of a mirror image, and no one has more nearly approximated the transparency of Blake's vision.

Beside the baker, the local printer collected Vermeers: Jacob Dissius owned nineteen of them by 1682, and he added two later. (It was his collection which was dispersed in the Amsterdam auction of 1696.) Thoré, who rediscovered Vermeer in the 1840s, placed him in the circle of Rembrandt; Han van Meegeren, who forged him in the 1930s, implied the presence of Caravaggio.[16] Neither version of the artist resembles the master we think we know. Other eyes have not failed to notice photographic clarity and phenomenological purity, impressionist sensation, and abstract structure. And now that Clio has finally blown her trumpet, Vermeer has not merely—despite himself—become famous; he has been assumed into the pantheon of Pop.[17] It has been a long day since van Gogh asked Emile Bernard: "Do you know a painter named Jan Van der Meer?", this painter whose spell resists our question, who said exactly what he had to say without bothering about anything else.

Notes

1. Thirty-five according to Ludwig Goldscheider [*Johannes Vermeer, The Paintings* (London: Phaidon, 1967)] and Lawrence Gowing [*Vermeer* (New York: Harper & Row, 1970)], authorities whom, by and large, I follow. A few scholars doubt the authenticity of the *Girl with a Red Hat* and the *Girl with a Flute,* and there are some lesser difficulties in attribution. The *œuvre* has not been standardized in every detail to everyone's satisfaction, but no consensus of opinion reducing it to thirty paintings or raising it to forty is presently foreseeable. I take as authentic the Frick *Lady Receiving a Letter from Her Maid* which Gowing regards as "dubious" (p. 78, n. 6), but I hesitate to attribute to Vermeer the *Lady Seated at the Virginals* (formerly of the Beit Collection, Blessington, Ireland), which (Gowing writes) "appears to be from his hand" (p. 5). Although only two of the paintings are dated, the "general outline of the chronology is clear" (Gowing, p. 78, n. 6). Needless to say, there is a certain amount of dispute. I accept Gowing's approximation, and although I do not discuss every painting in chronological sequence, I have followed the "general outline."

2. Théophile Thoré (called William Bürger), "Van der Meer de Delft," *Gazette des Beaux-Arts* XXI (1886): 297-330, 458-70, 542-75. In 1842, while visiting the Hague, Thoré noticed "a strange painting" which surprised him, he said, as much as Rembrandt's *Anatomy Lesson.* "Not knowing to whom to attribute it, I consulted the catalogue: '*View of the City of Delft,* from the side of the canal, by Jan van der Meer of Delft.' *Tiens!* Here's one we don't know in France and whom we ought to know!" Thoré tracked down many of Vermeer's paintings through years of political exile and delineated an *œuvre.* Though he largely misread Vermeer under the sign of Rembrandt, he never doubted he was in possession of the works of a very great master.

3. André Malraux, *Vermeer de Delft* (Paris: NRF, 1952), pp. 15-24.

4. Gowing, *Vermeer,* p. 19. Gowing's is a brilliant book despite this disfiguring passage.

5. Pierre Descargues, *Vermeer* (trans. James Emmons) (Geneva: Skira, 1966), pp. 107-8.

6. *The Complete Paintings of Vermeer,* Introduction by John Jacob (New York: Harry N. Abrams, 1967), p. 7. Or see Philip L. Hale, *Jan Vermeer of Delft* (Boston: Small, Maynard, 1913), p. 23 for yet another variant: "He [Vermeer] saw as a man cured of congenital blindness might see—absolutely without prejudice."

7. Slightly reset from Descargues, p. 62. Or see Jakob Rosenberg, Seymour Slive, and E.H. ter Kuile, *Dutch Art and Architecture: 1600-1800* (Baltimore: Penguin Books, 1972), p. 212: "as far as we know, Vermeer, the father of eleven, never painted a child." According to recent research, he fathered at least twelve children. See J.M. Montias, "Vermeer and His Milieu: Conclusion of an Archival Study," *Oud Holland* XCIV (1980): 60.

8. Slightly reset from Horst Gerson, ed., *Seven Letters by Rembrandt,* transcribed by Isabella H. van Eeghen, trans. Yda D. Ovink (The Hague: L.J.C. Boucher, 1961), pp. 9-10.

9. Lawrence Gowing, *Vermeer* (New York: Barnes and Noble, 1962), p. 12. Vitale Bloch, *All the Paintings of Jan Vermeer,* trans. Michael Kitson (New York: Hawthorn Books, 1963), p. 19.

10. Paul Zumthor, *Daily Life in Rembrandt's Holland,* trans. Simon Watson Taylor (New York: MacMillan Co. 1963), p. 37.

11. Paul Claudel, *The Eye Listens,* trans. Elsie Pell (New York: The Philosophical Library, 1950), p. 16.

12. P.T.A. Swillens, *Johannes Vermeer, Painter of Delft 1632-1675,* trans. C.M. Breuning-Williamson (Utrecht: Spectrum Publishers, 1950), pp. 69-77. Vermeer's father purchased three-storied Mechelen, "the largest house in its neighborhood," in 1641, probably in March, and kept a tavern on the ground floor. The Vermeers had formerly lived on the Voldersgracht, a street parallel to Market Square on its north side, from at least January 1635 to 17 February 1638, when Vermeer's parents drew up their testament. See J.M. Montias, "New Documents on Vermeer and His Family," *Oud Holland* XCI (1977): 276-77. In "Vermeer and His Milieu," p. 44, Montias informs us that the house on the Voldersgracht Vermeer's father rented was an inn called *De Vliegende Vos* (The Flying Fox); Montias thinks it likely Vermeer was born in this inn.

13. Slightly reset from Gaston Bachelard, *The Poetics of Space,* trans. Maria Jolas (New York: The Orion Press, 1964), p. 7.

14. Bernard Berenson, *The Italian Painters of the Renaissance* (Cleveland: World Publishing Company, 1968), p. 199.

15. Bachelard, *Poetics of Space* p. 138. My previous sentence paraphrases Bachelard.

16. David M. Robb, "The Iconography of the Annunciation in the Fourteenth and Fifteenth Centuries," *Art Bulletin* XVIII (1936): 485, n. 21.

17. Erwin Panofsky, *Early Netherlandish Painting,* vol. 1 (New York: Harper and Row, 1971), p. 144.

18. Gowing, *Vermeer,* p. 100.

19. Goldscheider, *Johannes Vermeer,* p. 18.

20. Bachelard, *Poetics of Space,* pp. 25-26.

21. Ibid., p. 18.

22. Panofsky, *Early Netherlandish Painting,* p. 132. "The tower—in recollection of the myth of Danaë who was imprisoned in a *turris aenea* in order to protect her from any intercourse with men—was a recognized symbol of chastity, not only in representations of this virtue in general...but also with reference to the Annunciation in particular...."

23. Paul Claudel, *L'oeil Ecoute* (Paris: Gallimard, 1946), p. 24.

24. Daniel A. Fink, "Vermeer's Use of the Camera Obscura—A Comparative Study," *Art Bulletin* LIII (1971): 500. Her image is "also unsaturated owing to the scattering and transmission of light in the window."

25. Hale, *Jan Vermeer,* pp. 259-60.

26. Bachelard, *Poetics of Space* p. 222. The phrase "houses for things" in this paragraph is also Bachelard's.

27. Robb, "Iconography," pp. 503-4.

28. Panofsky, *Early Netherlandish Painting*, p. 141.

29. Ibid., p. 142.

30. I use Panofsky in this paragraph and the next as a source book for "disguised symbols" in early Netherlandish painting. See his chapter "Reality and Symbol," pp. 131-48.

31. An X-ray of the *Girl Asleep at a Table* reveals that Vermeer painted a dog in the doorway, then painted him out. See Hubert von Sonnenburg, "Technical Comments" (On Vermeer's paintings) *The Metropolitan Museum of Art Bulletin* XXXI (Summer 1973): fig. 95.

32. Descargues, *Vermeer*, p. 38.

33. Slightly reset from Bachelard, *Poetics of Space*, p. 215.

34. Ibid., p. 13.

35. Descargues, *Vermeer*, p. 38.

36. Eugène Fromentin, *The Old Masters of Belgium and Holland*, trans. Mary C. Robbins (New York: Schocken Books, 1963), p. 278.

37. Jan Veth, Gemälde von Johannes Vermeer," *Kunst und Künstler* 8 (1910): 116.

38. Charles Seymour, "Dark Chamber and Light-Filled Room: Vermeer and the Camera Obscura," *Art Bulletin* XLVI (1964): 326.

39. Slightly reset from Rosenberg, Slive, and ter Kuile, *Dutch Art and Architecture*, p. 196.

Chapter 2

1. Jean Piaget and Bärbel Inhelder, *The Child's Conception of Space*, trans. F.J. Langden and J.L. Lunzer (London: Routledge & Kegan Paul, 1956), pp. 3-8.

2. William Ivins, Jr., *On the Rationalization of Sight* (New York: Da Capo Press, 1973).

3. Gaston Bachelard, *The Poetics of Space*, trans. Maria Jolas (New York: The Orion Press, 1964), p. 237.

4. Ibid., p. 240.

5. Ibid., p. 239. ("The round being propagates roundness, together with the calm of all roundness.")

6. Lawrence Gowing, *Vermeer* (New York: Harper & Row, 1970), p. 81.

7. *The Modern Reader's Bible*, ed. Richard G. Moulton (New York: MacMillan, 1939), p. 1110. The episode is Luke 10: 38 ff.

8. Erich Heller, *The Artist's Journey into the Interior and Other Essays* (New York: Random House, 1965).

9. Arthur K. Wheelock, Jr. informs us that "close observation of the painting makes it evident that no gold exists in the scales." The traditional title is evidently a misnomer, and at the National Gallery (in Washington, D.C.) the painting has been reentitled *A Woman Holding a Balance*. See Wheelock's review of Albert Blankers *Johannes Vermeer van Delft, 1632-1675* in the *Art Bulletin* LIV (1977) 439-41.

10. Mircea Eliade, *The Sacred and the Profane*, trans. Willard R. Trask (New York: Harcourt, Brace, 1959), p. 44.

11. Gowing, *Vermeer*, pp. 114, 113.

12. A.P. Mirimonde, "Les Sujets Musicaux Chez Vermeer de Delft," *Gazette des Beaux-Arts* LVII (1961): 46. But if the woman does not hold snakes but a bridle, then she may represent not "la dangereuse dialectique" but an allegory of Temperance—and we should associate her not with the tempter in the room but the elder on the wall. See Arthur K. Wheelock, Jr., *Vermeer* (New York: Harry N. Abrams, 1981), p. 92.

13. The half-eaten pieces of fruit and the coil of rind are common motifs in seventeenth century Dutch still-life painting, and I would not claim they always carry symbolic import. Only that they carry it in Vermeer. See Ingvar Bergström, *Dutch Still-Life Painting in the Seventeenth Century*, trans. Christina Hedstrom and Gerald Taylor (New York: T. Yoseloff, 1956).

14. Elias Canetti, *Crowds and Power*, trans. Carol Stewart (New York: Viking Press, 1962), p. 172.

15. Marcel Brion reminds us of the metaphorical presence of ocean in these interiors and of the literal presence of the sea in the daily life of the painter. "These calm interiors are disturbed only by the turbulent waves of the multi-colored carpets, suggesting the ocean; the call of the sea and the lure of adventure are just outside one's front door, in the small lapping waves of the Dutch canals." Marcel Brion, *Vermeer*, trans. Sally Marks (New York: Harry N. Abrams, 1963), p. 76.

16. Erwin Panofsky, *Early Netherlandish Painting*, vol. 1 (New York: Harper and Row, 1971), p. 231.

17. I have suggested that the *View of Delft* is something more than a topographical view; Wheelock suggests that it is something less. In truth, it is both more and less. Wheelock compares Vermeer's painting with a drawing by Abraham Rademaker, a *View of Delft with Schiedam and Rotterdam Gates,* and concludes that the *View of Delft* "is not a totally accurate topographical representation of the city.... Vermeer compressed the cityscape into a dense frieze by simplifying the city's profile and spreading out its forms." Wheelock, *Vermeer*, pp. 33, 94.

18. Marcel Proust, *The Captive*, trans. C.K. Scott Moncrieff vol. 2 (New York: Random House, 1934), p. 509.

19. Bachelard, *Poetics of Space*, p. 222.

20. Gowing, *Vermeer*, p. 52.

21. Ibid., pp. 138, 19. For a particularly sensitive and poetic analysis of this painting, see Edward A. Snow, *A Study of Vermeer* (Berkeley: University of California Press, 1979), pp. 3-21.

22. Bachelard, *Poetics of Space*, chapter 8.

Chapter 3

1. Harry Berger, Jr., "Conspicuous Exclusion in Vermeer: An Essay in Renaissance Pastoral," *Yale French studies* 47 (1973): 243-65.

2. K.G. Hultén, "Zu Vermeers Atelierbild," *Konsthistorisk Tidskrift* XVIII (1949): 92.

3. Lionel Abel, *Metatheatre* (New York: Hill and Wang, 1963), pp. 60, 60.

4. Charles de Tolnay, "L'Atelier de Vermeer," *Gazette des Beaux-Arts* XLI (1953): 268.

5. Ibid., p. 293.

6. James A. Welu, "Vermeer: His Cartographic Sources," *Art Bulletin* LVII (1975): 541, n. 62.

7. Frances Margaret Blanshard, *Retreat from Likeness* (New York: Columbia University Press, 1945).

8. Paul Zumthor, *Daily Life in Rembrandt's Holland,* trans. Simon Watson Taylor (New York: MacMillan Co., 1963), p. 138.

9. For the glass globe, see E. de Jongh, "Pearls of Virtue and Pearls of Vice," *Simiolus* 8 (1975/1976): 74.

10. Welu, "Vermeer," pp. 542-43.

11. Jongh ("Pearls," pp. 74-75) suggests that the *Painter in His Studio* may have been made for the Delft artists' guild of St. Luke, the *Allegory of the New Testament* for the local Jesuits.

12. Gowing does not date the *Head of a Young Woman;* the date given is Ludwig Goldscheider's, *Johannes Vermeer, The Paintings,* (London: Phaidon, 1967), p. 134.

13. Gaston Bachelard, *The Poetics of Space,* trans. Maria Jolas (New York: The Orion Press, 1964), p. 6.

14. Erwin Panofsky, *Early Netherlandish Painting,* vol. 1 (New York: Harper and Row, 1971), p. 138.

15. Bachelard, *Poetics of Space,* p. 47.

16. R.H. Wilenski, *Dutch Painting* (London: Faber and Faber, 1955), p. 189.

17. For the Chinese screen, see Lawrence Gowing, *Vermeer* (New York: Harper & Row, 1970), 59.

18. The date is Goldscheider's, *Vermeer,* p. 132. Although some question the authenticity of the curtain behind the figures, "the last cleaning, in 1953, revealed that the complete curtain is original, although it may have been left unfinished by the painter." See *The Frick Collection,* compiled by Bernice Davidson, vol. 1 (New York, 1968), p. 296.

19. I have drawn the dates and places in this paragraph from J.M. Montias, "Vermeer and His Milieu: Conclusion of an Archival Study," *Oud Holland* XCIV (1980) 44-62.

20. Bachelard, *Poetics of Space,* p. 67.

21. Millard Meiss, *French Painting in the Time of Jean de Berry,* vol. 2 (London: Phaidon, 1969), plate 20.

22. Madlyn Millner Kahr, *Dutch Painting in the Seventeenth Century* (New York: Harper and Row, 1978), p. 296.

23. John Lukacs, "The Bourgeois Interior," *The American Scholar* 39 (1970): 622, 623.

Chapter 4

1. As quoted in *The Complete Paintings of Vermeer,* Introduction by John Jacob (New York: Harry N. Abrams, 1967), p. 11.

2. Charles de Tolnay, "L'Atelier de Vermeer," *Gazette des Beaux-Arts* XLI (1953): 271.

3. *The Berlin-Dahlem Gallery,* Introduction and Commentary by Edwin Redslob, trans. Sophie Wilkins (New York, 1967), p. 233.

4. José Ortega y Gasset, "On Point of View in the Arts," *The Dehumanization of Art* (Garden City: Doubleday & Co., 1956), p. 117.

5. Pierre Descargues, *Vermeer*, trans. James Emmons (Geneva: Skira, 1966), p. 105.

6. Arthur K. Wheelock, Jr. has noticed that in a *Woman Holding a Balance* (formerly the *Lady Weighing Gold*) Vermeer "shifted the height of the bottom edge of the picture frame" as it passes behind the Woman. [Arthur K. Wheelock, Jr. *Vermeer* (New York: Harry N. Abrams, 1981), p. 100.] We may notice that in the *Love Letter* he shifts the height of the bottom edge of the picture frame as it passes behind the maid—as well as the height of the bottom and top edges of the gilded leather panel as it passes behind maid and mistress. I would not necessarily ascribe these realignments solely to compositional demand, for it is possible that Vermeer is aware that when an opaque body lies across a straight line, the line no longer seems straight but as if of two unjoinable segments. Cézanne's observance of this optical illusion in some of his still-lifes earned him the early accusation of not being able to draw (a straight line). Less dramatically, Vermeer may also be acknowledging this curious effect as a way of giving full value to visual data.

7. André Lhote, *Theory of Figure Painting*, trans. W.J. Strachan (New York, 1954), p. 165.

8. Lawrence Gowing, *Vermeer* (New York: Harper and Row, 1970). p. 23.

9. *Picasso on Art*, ed. Dore Ashton (New York: Viking Press, 1972), p. 167.

10. Hans Bolliger, *Picasso's Vollard Suite*, trans. Norbert Guterman (New York: Harry N. Abrams, 1977), p. XII.

11. Fleur Cowles, *The Case of Salvador Dali* (Boston: Little, Brown, 1959), p. 233.

12. Jean Lipman and Richard Marshall, *Art About Art* (New York: E.P. Dutton, 1978), p. 85.

13. Herman Kühn, "A Study of the Pigments and the Grounds Used by Jan Vermeer," *Reports and Studies in the History of Art* (Washington: The National Gallery of Art), II (1968): 155-202.

14. Roland Barthes, "The World as Object," *Critical Essays*, trans. Richard Howard (Evanston: Northwestern University Press, 1972), pp. 3-12.

15. Aldous Huxley, *The Doors of Perception* (New York: Harper & Row, 1970), p. 39.

16. For the life and death of van Meegeren, see Lord Kilbracken, *Van Meegeren: A Case History* (London: Nelson, 1967). For the scientific evidence demonstrating forgery, see P.B. Coremans, *Van Meegeren's Faked Vermeers and De Hooghs*, trans. A. Hardy and C.M. Hutt (London: Cassel Co., 1949).

17. Pop in the sense that the *Painter in His Studio* has become a familiar and serviceable icon for purposes of parody and irony. See Jean Lipman and Richard Marshall, *Art About Art* (New York: E.P. Dutton, 1978), pp. 80-84 for recent examples. Vermeer, who had eluded Picasso and Miró and who had (I fear) overwhelmed Dali, has become part of the usable truth for such contempoary Americans as Malcolm Morley, Sante Graziani, and George Deem. See also Udo Kultermann, "Vermeer in Contemporary American Painting," *American Art Review* IV/6 (1978): 114-19.

Bibliography

Abel, Lionel. *Metatheatre*. New York: Hill and Wang, 1963.

Alpers, Svetlana. *The Art of Describing. Dutch Art in the Seventeenth Century*. Chicago: The University of Chicago Press, 1983.

Ashton, Dore (ed). *Picasso on Art*. New York: Viking Press, 1972.

Bachelard, Gaston. *The Poetics of Space*. Translated by Maria Jolas. New York: The Orion Press, 1964.

Badt, Kurt. *Modell und Maler von Jan Vermeer*. Köln: M. DuMont Schauberg, 1961.

Barthes, Roland. "The World as Object." *Critical Essays*. Translated by Richard Howard. Evanston: Northwestern University Press: 1972, 3-12.

Berenson, Bernard. *The Italian Painters of the Renaissance*. Cleveland: World Publishing Company, 1968.

Berger, Harry, Jr. "Conspicuous Exclusion in Vermeer: An Essay in Renaissance Pastoral." *Yale French Studies* 47 (1973): 243-65.

Berger, John. *The Moment of Cubism*. New York: Pantheon Books, 1969.

Bergström, Ingvar. *Dutch Still-Life Painting in the Seventeenth Century*. Translated by Christina Hedstrom and Gerald Taylor. New York: T. Yoseloff, 1956.

Bertram, Anthony. *Jan Vermeer of Delft*. London/New York: Studio Publications, 1948.

Blankert, Albert (with contributions by Rob Ruurs and Willem L. van de Watering). *Vermeer of Delft*. Translated by Hinke Boot-Tuinman and Gary Schwartz. Oxford: Phaidon, 1978.

Bloch, Vitale. *All the Paintings of Jan Vermeer*. Translated by Michael Kitson. New York: Hawthorn Books, 1963.

Bolliger, Hans. *Picasso's Vollard Suite*. Translated by Norbert Guterman. New York: Harry N. Abrams, 1977.

Brion, Marcel. *Vermeer*. Translated by Sally Marks. New York: Harry N. Abrams, 1963.

Bürger, William (Théophile Thoré). "Van der Meer de Delft." *Gazette des Beaux-Arts* XXI (1866): 297-330, 458-70, 543-75. Reprinted in A. Blum. *Vermeer et Thoré-Bürger*. Geneva: Les Editions du Mont-Blanc, 1945.

Canetti, Elias. *Crowds and Power*. Translated by Carol Stewart. New York: Viking Press, 1962.

Clark, Kenneth. *Looking at Pictures*. Boston: Beacon Press, 1960.

Claudel, Paul. *L'œil Ecoute*. Paris: Gallimard, 1946. Translated by Elsie Pell as *The Eye Listens*. New York: The Philosophical Library, 1950.

Coremans, P.B. *Van Meegeren's Faked Vermeers and De Hooghs*. Translated by A. Hardy and C.M. Hutt. London: Cassell & Co., 1949.

Cowles, Fleur. *The Case of Salvador Dali*. Boston: Little, Brown, 1959.

Davidson, Bernie (compiler). *The Frick Collection*. 2 vols. Princeton, N.J.: Princeton University Press, 1968.

Descargues, Pierre. *Vermeer*. Translated by James Emmons. Geneva: Skira, 1966.

Diehl, Gaston. *Vermeer*. Translated by Lucy Norton. New York: The Hyperion Press, n.d.

Eliade, Mircea. *The Sacred and the Profane.* Translated by Willard R. Trask. New York: Harcourt, Brace, 1959.

Fink, Daniel A. "Vermeer's Use of the Camera Obscura—A Comparative Study." *Art Bulletin* LIII (1971): 493-505.

Friedlander, Max J. *Landscape Portrait Still-Life.* Translated by R.F.C. Hull. New York: Schocken Books, 1965.

Fromentin, Eugène. *The Old Masters of Belgium and Holland.* Translated by Mary C. Robbins. New York: Schocken Books, 1963.

Gelder, J.G. van. *De Schilderkunst van Jan Vermeer* (with a commentary by J.A. Emmens). Utrecht: Kunsthistorisch Instituut, 1958.

Gerson, Horst (ed). *Seven Letters by Rembrandt.* Transcribed by Isabella H. van Eeghen, translated by Yda D. Ovink. The Hague: L.J.C. Boucher, 1961.

Goldscheider, Ludwig. *Johannes Vermeer, The Paintings.* London: Phaidon, 1967.

Gowing, Lawrence. "Light on Baburen and Vermeer." *Burlington Magazine* XCIII (1951): 169-70.

_____. *Vermeer.* New York: Barnes and Noble, 1962.

_____. *Vermeer.* New York: Harper & Row, 1970.

Hale, Philip L. *Jan Vermeer of Delft.* Boston: Small, Maynard, 1913.

Huizinga, Johan. *Dutch Civilization in the Seventeenth Century and Other Essays.* Translated by Arnold J. Pomerans. New York: Harper & Row, 1969.

Hultén, K.G. "Zu Vermeers Atelierbild." *Konsthistorisk Tideskrift* XVIII (1949): 89-98.

Huxley, Aldous. *The Doors of Perception.* New York: Harper & Row, 1970.

Huyghe, René. "Vermeer et Proust." *Gazette des Beaux-Arts* XVII (1936): 7-15.

Jacob, John (Introduction). *The Complete Paintings of Vermeer.* New York: Harry N. Abrams, 1967.

Jongh, E. de. "Pearls of Virtue and Pearls of Vice." *Simiolus* 8 (1975/1976): 69-97.

Kahr, Madlyn Millner. *Dutch Paintings in the Seventeenth Century.* New York: Harper & Row, 1978.

_____. "Vermeer's Girl Asleep, A Moral Emblem." *Metropolitan Museum Journal* XI (1972): 115-32.

Kilbracken, Lord. *Van Meegeren: A Case History.* London: Nelson, 1967.

Koningsberger, Hans. *The World of Vermeer.* New York: Time, Inc., 1967.

Kühn, Herman. "A Study of the Pigments and the Grounds Used by Jan Vermeer." *Reports and Studies in the History of Art.* Washington: The National Gallery of Art II (1968): 155-202.

Kultermann, Udo. "Vermeer in Contemporary American Painting." *American Art Review* IV/6 (1978): 114-19, 139-40.

Lipman, Jean and Marshall, Richard. *Art About Art.* New York: E.P. Dutton, 1978.

Lukacs, John. "The Bourgeois Interior." *The American Scholar* 39 (1970): 616-30.

Malraux, André. *Vermeer de Delft.* Paris: NRF, 1952.

Mayor, A. Hyatt. "The Photographic Eye." *The Metropolitan Museum of Art Bulletin* V (1946): 15-26.

Meiss, Millard. *French Paintings in the Time of Jean de Berry.* 2 vols. London: Phaidon, 1969.

Meltzoff, Stanley. "The Rediscovery of Vermeer." *Marsyas* II (1942): 145-66.

Mirimonde A.P. "Les Sujet's Musicaux Chez Vermeer de Delft." *Gazette des Beaux-Arts* LVII (1961): 29-52.

Montias, J.M. *Artists and Artisans in Delft. A Socio- Economic Study of the Seventeenth Century.* Princeton: Princeton University Press, 1982.

_____. "New Documents on Vermeer and His Family." *Oud Holland* XCI (1977): 267-87.

_____. "Vermeer and His Milieu: Conclusion of an Archival Study." *Oud Holland* XCIV (1980): 44-62.

Ortega y Gasset, José. "On Point of View in the Arts." *The Dehumanization of Art.* Garden City: Doubleday & Co., 1956.

Panofsky, Erwin. *Early Netherlandish Painting.* 2 vols. New York: Harper & Row, 1971.

Perl, Jed. "Johannes Vermeer's Young Woman with a Water Jug." *Arts Magazine* LIII/5 (1979): 118-21.

Piaget, Jean and Inhelder, Bärbel. *The Child's Conception of Space.* Translated by F.J. Langden and J.L. Lunzer. London: Routledge & Kegan Paul, 1956.

Pops, Martin. *Vermeer: An Anthology of Criticism. Salmagundi* 44-45 (1979): 3-146 (with contributions by Berger, Claudel, Gowing, Huyghe, Malraux, Pops, Read, Semprun, Serres, and Snow).

Proust, Marcel. *Remembrance of Things Past.* 2 vols. New York: Random House, 1934.

Read, Herbert. "The Serene Art of Vermeer." *Art and Alienation.* New York: Viking Press, 1967: 87-93.

Robb, David M. "The Iconography of the Annunciation in the Fourteenth and Fifteenth Centuries." *Art Bulletin* XVIII (1936): 480-526.

Rosenberg, Jakob; Slive, Seymour; and ter Kuile, E.H. *Dutch Art and Architecture: 1600-1800.* Baltimore: Penguin Books, 1972.

Salomon, Nanette. "Vermeer and the Balance of Destiny." *Essays in Northern European Art Presented to Egbert Haverkamp—Begeman.* Groningen: Davaco, 1983: 216-21.

Schwarz, Heinrich. "Vermeer and the Camera Obscura." *Pantheon* XXIV (1966): 170-80.

Semprum, Jorge. *The Second Death of Ramòn Mercader.* Translated by Len Ortzen. New York: Grove Press, 1973.

Serres, Michel. "L'Ambroisie et l'or." *Hermes III La Traduction.* Paris: Les Editions de Minuit, 1974.

Seymour, Charles. "Dark Chamber and Light-Filled Room: Vermeer and the Camera Obscura." *Art Bulletin* XLVI (1964): 323-31.

Slive, Seymour. "Notes on the Relationship of Protestantism to Seventeenth Century Dutch Painting." *Art Quarterly* XIX (1956): 3-13.

Snow, Edward A. *A Study of Vermeer.* Berkeley: University of California Press, 1979.

Sonnenburg, Hubert von. "Technical Comments." The Metropolitan Museum of Art Bulletin XXXI (1973): unpaginated.

Stechow, Wolfgang. *Dutch Landscape Painting of the Seventeenth Century.* London: Phaidon, 1966.

_____. "Landscape Paintings in Dutch Seventeenth-Century Interiors." *Netherlands Kunsthistorisch Jaarboek* XI (1960): 165-84.

Swillens, P.T.A. *Johannes Vermeer, Painter of Delft 1632-1675.* Translated by C.M. Breuning-Williamson. Utrecht: Spectrum Publishers, 1950.

Thienen, Frithjof, *Jan Vermeer of Delft.* New York: Harper and Brothers, 1949.

Tolnay, Charles de. "L'Atelier de Vermeer." *Gazette des Beaux-Arts* XLI (1953): 265-72.

Veth, Jan. "Gemälde von Johannes Vermeer." *Kunst und Künstler* 8 (1910): 102-14.

Vries, A.B. de. *In the Light of Vermeer.* New York: Arno/Worldwide, 1967 (Catalogue for an Exhibition at The Hague).

_____. *Jan Vermeer van Delft.* Translated by Robert Allen. London/New York: B.T. Batsford, 1948.

_____. *Vermeer.* New York: Collins, 1967.

Walsh, John Jr. "Vermeer." *The Metropolitan Museum of Art Bulletin* XXXI (1973): unpaginated.

Welu, James A. *Vermeer: His Cartographic Sources."* Art Bulletin LVII (1975): 529-47.

Wheelock, Arthur K. Jr. "Albert Blankert, *Johannes Vermeer van Delft 1632-1675* (with contributions from Rob Ruurs and Willem L van de Watering)." *Art Bulletin* LIV (1977): 439-41 (Book Review).

_____. *Vermeer.* New York: Harry N. Abrams, 1981.

Wilenski, R.H. *Dutch Painting.* London: Faber and Faber, 1955.

Wright, Christopher, *Vermeer*. London: Oresko, 1976.

Zumthor, Paul. *Daily Life in Rembrandt's Holland*. Translated by Simon Watson Taylor. New York: MacMillan Co., 1964.

Index